IMAGES
of America

THE GALISTEO BASIN AND CERRILLOS HILLS

D1597151

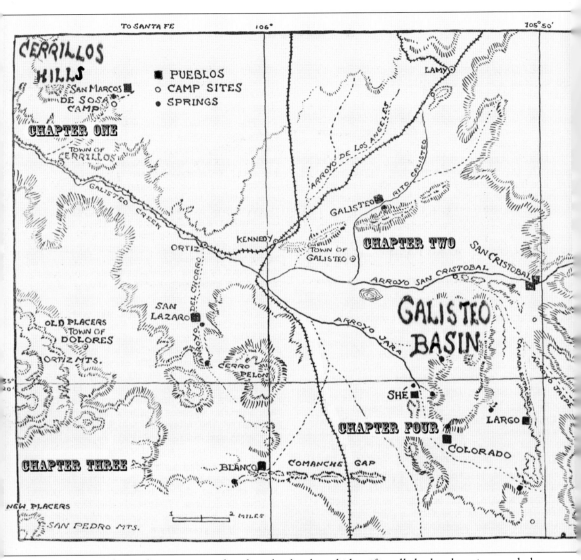

■ PUEBLOS
o CAMP SITES
• SPRINGS

CERRILLOS HILLS

San Marcos ■
DE SOSA CAMP o

CHAPTER ONE

TOWN OF CERRILLOS

GALISTEO CREEK

LAMY o

ARROYO DE LOS ANGELES

RITO GALISTEO

GALISTEO ■

KENNEDY o

CHAPTER TWO

SAN CRISTOBAL

ORTIZ o

ARROYO DEL CHORRO

TOWN OF GALISTEO o

ARROYO SAN CRISTOBAL

SAN LAZARO ■

OLD PLACERS
TOWN OF DOLORES

ORTIZ MTS.

CERRO PELON

ARROYO JARA

GALISTEO BASIN

CAÑADA ESTACADO

ARROYO JASPE

SHÉ ■

CHAPTER FOUR

LARGO ■

COLORADO

CHAPTER THREE

BLANCO ■

COMANCHE GAP

NEW PLACERS

SAN PEDRO MTS.

1 2 MILES

This map shows the area covered within this book and identifies all the key locations and place names, as well as the areas addressed by individual chapters. (Paul R. Secord.)

ON THE COVER: This photograph, titled "A Prospecting Party," was taken by George C. Bennett (1846–1915) of Bennett & Brown Photographers, Santa Fe, in the spring of 1880. Signatures on the reverse imply that it was given to New Mexico governor LeBaron Bradford Prince (1840–1922) by Mike O'Neil, who was Bennett's partner in several Cerrillos mines, including the Blue Bell Mine turquoise claim, an area that had been mined for over 1,000 years. In 1883, the Palace Hotel in Santa Fe bought 6,000 stereographic slides from Brown before he moved to Parral, Mexico. (Homer E. Milford.)

IMAGES
of America

THE GALISTEO BASIN AND CERRILLOS HILLS

Paul R. Secord and Homer E. Milford

ARCADIA
PUBLISHING

Copyright © 2018 by Paul R. Secord and Homer E. Milford
ISBN 978-1-4671-2718-9

Published by Arcadia Publishing
Charleston, South Carolina

Printed in the United States of America

Library of Congress Control Number: 2017961416

For all general information, please contact Arcadia Publishing:
Telephone 843-853-2070
Fax 843-853-0044
E-mail sales@arcadiapublishing.com
For customer service and orders:
Toll-Free 1-888-313-2665

Visit us on the Internet at www.arcadiapublishing.com

To our friends historian Bill Baxter (1943–2015), whose dedicated scholarship has greatly enhanced our understanding of the region explored in these pages—because of Baxter, this is a much more comprehensive effort; and Bill Henderson (1923–2015), a lifelong resident of Golden, New Mexico, whose extensive collection of cherished family photographs and documents, along with his knowledge of local history, made large parts of this book possible.

CONTENTS

ACKNOWLEDGMENTS

Many people helped make this book possible. We would like to especially thank the staff of the American Museum of Natural History, New York, for allowing over 30 photographs from the 1912 Nels C. Nelson expedition to the Galisteo Basin to be reproduced here; in particular, David Hurst Thomas, doctor of science, curator of the Division of Anthropology; and Kristen Mable, senior registrar for Archives & Loans, Division of Anthropology. Thanks also go to Stuart Dunlap and Bill Sisk of the Man's Hat Shop in Albuquerque for commentary, Joe Mildenberger for the drawing on page 74, and J. Scott Altenbach, professor emeritus, University of New Mexico, for his insight into New Mexico mining. Thanks as well to Desri and Allen Pielhau of Golden, New Mexico, and Patricia and Todd Brown of Cerrillos, New Mexico, for invaluable contributions.

Special thanks go to those who proofread and commented on the text: Gordon Bronitsky, Diane Comb, Barbara Chavez, and Marcia Secord.

We would also like to thank the staff at Arcadia Publishing for their rapid response to all our questions and for making it easy to bring this project in on schedule; lastly, a most heartfelt thanks to friends and associates, without whom this book would not exist.

The images in this volume appear courtesy of:

AAS	Albuquerque Archaeological Society reports, Hibben Center, University of New Mexico
AMNH	American Museum of Natural History, Nels C. Nelson Archive, New York
B&B	Bennett and Brown photographs in the collection of Homer Milford
BD	Bertha Dutton, from "Pueblo Largo (LA183)," Maxwell Museum Technical Series No. 23, 2015, University of New Mexico
CSWR	New Mexico Center for Southwest Research, University of New Mexico
DD	Diane Drobka collection of Indian Detour Lantern Slides, Tucson
FRL	Fine Arts Library, University of New Mexico
GM	Greg MacGregor, courtesy of the Photo-Eye Gallery, Santa Fe
HABS	US Historic American Building Survey, Washington, DC
HR	Henderson and Riccon Collection, courtesy of Desiri and Allen Pielhau, Golden
MAC	Homer E. Milford, Albuquerque
NMG	New Mexico Bureau of Geology & Mineral Resources, Socorro
NMSRCA	New Mexico State Records Center and Archives, Santa Fe
NRHP	National Register of Historic Places, Washington, DC
SAC	Paul R. Secord, Albuquerque
TPB	Todd and Patricia Brown collection, Cerrillos
USNA	US National Archives and Records Administration, Washington, DC

INTRODUCTION

This book fills in an important gap in the ongoing survey of New Mexico history contained in Arcadia Publishing's Images of America series. Past books have looked at *Pecos, The Turquoise Trail*, and *Towns of the Sandia Mountains*. But just south of Santa Fe and Pecos and east of the Sandia Mountains—that dramatic backdrop for Albuquerque—is some fascinating history. Until recently, this part of New Mexico was quite neglected. However, with increased tourism along scenic Highway 14 from Santa Fe through the no longer ghost town of Madrid, and on to Interstate 40 and Albuquerque, coupled with the establishment of Cerrillos Hills State Park and the Galisteo Basin Preserve, this region is finally receiving some long overdue attention.

In the pages that follow we will see evidence of prehistoric turquoise mining representing some of the earliest documented mining in what is now the United States, as well as the site of the first major gold strike in the United States. Also discussed is the first European road from what is now the continental United States to Mexico City and enormous prehistoric Native American towns, called *pueblos*, which are only now becoming partially understood.

The Cerrillos Hills, along with the Ortiz and San Pedro Mountains and South Mountain, are all remnants of 30-plus-million-year-old volcanic eruptions and uplifts through sedimentary rocks. It is in places such as these that mineralization may occur and subsequent mining is often found.

The adjacent Galisteo area to the east of this uplifted zone contains from 900 to 4,000 feet of sandstone, sand, and clay deposited by rivers in a broad, deep inland basin, and some volcanic activity.

People have moved through this region for as long as 12,000 years. However, only one site, dated at about 10,500 years ago, is documented from the Paleoindian period (12,000–5,500 BC) in the Galisteo Basin. Most such early remains are buried deep below the surface.

Human occupation of the Galisteo Basin does not become significant until a brief period between the 13th and 16th centuries. It is at that time that a major influx of Puebloan peoples, farmers who lived in permanent villages/pueblos, moved into the area. Some of these pueblos were still occupied at the time of the Spanish arrival in the 1500s.

This Pueblo occupation is highly complex, and there are indications of dramatic interactions between different types of Native Americans who undoubtedly spoke different languages and had different belief systems.

Sixteenth- and seventeenth-century Spanish exploration into New Mexico, including the 1540 Coronado Expedition, passed through the area of study. Contrary to popular belief, the Spanish were searching not only for gold; they were really looking for the same type of rich state-level civilizations they had found in Mexico, such as that of the Aztecs, as well as the Inca civilization in what is now Peru. Equally if not more important was finding a route to the riches of China including textiles, gold, and silver.

This all made perfect sense to the European colonists. They knew the world was round, so they realized that if they kept going west, they should get to the Far East. They just did not realize there were a couple of continents in between and just how big the earth really was.

After Coronado's expedition, there is an exploration gap of nearly 40 years, with only sporadic incursions into what is now New Mexico by the Spaniards. This was due to the Chichimeca War (1550–1590) between the Spanish colonizers and their Native American allies against a unified group of Mexican Chichimeca Indians in northern Mexico. Few were brave enough to cross the war zone to explore northern regions.

The first expedition after Coronado's was in 1581. They were primarily miners who collected silver ore samples and described and named a number of pueblos. The Royal Mint in Mexico City assayed (tested) three ore samples after the trip. The richest galena (lead-silver ore) came from the San Pedro Mountains near modern Golden (see chapter three). The second richest was from pueblo mines in the Cerrillos Hills (chapter one).

Starting out in July 1590, Spanish Colonial miners and their families under the leadership of Castano de Sosa moved to the Cerrillos area from Coahuila in eastern Mexico looking for the previously identified potentially productive silver deposits. Assays of samples found along their route north failed to yield adequate results. It took them over six months to get their carts to Cerrillos via Texas and the Pecos River. In January 1591, they chose a place by a spring near the modern town of Cerrillos to settle. This was the first effort to colonize what is now the United States west of the Mississippi River. In the process, these Cerrillos miners established the northern third of what we call the Camino Real or Royal Road to Mexico City, their wheel ruts marking the way for later travelers.

Unfortunately for them, their smelters produced very little silver, and after a few weeks, they decided to go to the silver deposits by modern Golden, which they named the Mines of Annunciation. A few days later, they were arrested for colonizing without proper approval.

Two of the Tlaxcalan (Native Americans who had been subjugated by the Aztecs and thus aligned themselves with the Spanish) members of the de Sosa Expedition stayed at Kewa (Santo Domingo) Pueblo and were translators for colonists in 1598.

Cerrillos remained the northern end of the Camino Real until 1598, when an additional 30 miles were added by the Oñate Expedition, giving the road its final length. Don Juan de Oñate's family had made a fortune in the Zacatecan mines and he was married to the granddaughter of the conqueror of Mexico, Hernán Cortés, and the great-granddaughter of the Aztec emperor Montezuma Xocoyotzin.

The Castano de Sosa colonization of New Mexico was approved in 1593, but he had died by then. Juan de Oñate resigned his post as governor of three frontier towns—one of which was Tlaxcalan in 1593—to pursue the right to replace Sosa as the colonizer of New Mexico. Most if not all the work in the Cerrillos mines during the Oñate era (1598–1610) was done by Tlaxcalan miners. Without giving a source, New Mexico historian Robert Julyan wrote that there were 700 Tlaxcalan colonists in 1598 who had come with Oñate. So, they greatly outnumbered the 200 or so Spanish colonists with the Oñate Expedition, a caravan that stretched two miles and included 80 wagons along with several thousand head of livestock when it crossed the Rio Grande into New Mexico. In a document from July 1600, most of Spanish Cerrillos mine owners described the miners as servants, but one called them his men. The 1591 Tlaxcalan Bill of Rights Law prohibited forcing them into servitude. They were guaranteed the right to found their own towns, carry guns, and leave the frontier when they wanted to do so.

In testimony taken in 1608 and signed by New Mexico governor Pedro de Peralta (1589–1666), a man leaving New Mexico claimed he was one of the founders of Santa Fe, as well as the discoverer of mines at the north end of the Sandia Mountains. A distinguished 18th-century New Mexico historian wrote that the purely Spanish town of Santa Fe was founded when Oñate returned from his trip to the Pacific Ocean, which implies there was a mixed ethnic town there before 1605. The Cerrillos miners' language was Nahuatl, and it appears they had a camp with some Spaniards as early as July 1600. One of the few surviving Nahuatl place names in New Mexico, other than Mount Chalchihuital in the Cerrillos Hills, is the Barrio of Analco in Santa Fe. *Analco* is Nahuatl for "next to the water"—A (water), *nal* (next to), and *co* (place of)—in this case, across the Santa Fe River.

The south side of the river in Santa Fe is more fertile and easier to water than the north side. So, it seems that the Spanish would have settled there if the Tlaxcalans had not been there first. Even in the late 1700s, Governor de Anza tried to kick the residents of Analco out and move the capitol to the south side of the river, but he was prohibited from doing so by higher officials. Viceroy Luis de Velasco's 1591 decree (bill of rights) for Tlaxcalans who moved to the frontiers prohibited Spanish settlement near their *barrios* (towns) for five years and allocated many other rights. Thus Oñate, a past governor of a Tlaxcalan town, would have known it was illegal to make a Spanish settlement in Santa Fe on the south side of the river until 1605. The earliest detailed map of Santa Fe, done in 1767, has a label for Analco and a note: "Town or neighborhood of Analco which owes its origins to the Tlaxcaltecas [sic] (from Talaxcala) who accompanied the early Spanish who entered for the conquest of this kingdom."

In 1602, the government in Spain granted Juan de Oñate the title of *adelantado*, so he must have sent the petition for it from New Mexico by 1601 or earlier. One of the major requirements for the title was the founding of two or more towns or forts. To the authors' knowledge, Analco is the only possibility for a second town in New Mexico. This all means that a significant component of the 1598 colonists of New Mexico who founded Santa Fe and mined in the Cerrillos Hills were Nahuatl-speaking Tlaxcalans from central Mexico.

The first significant European settlements in the Galisteo Basin were missions built between 1626 and 1660 by Franciscans at Galisteo, San Marcos, San Cristóbal, and San Lázaro Pueblos. But the area was largely abandoned by the late 1660s due to drought and Plains Indian raids, as well as economic and religious pressures. When the Spanish reconquered New Mexico under Diego de Vargas in 1692 after the 1680 Pueblo Revolt, they found the area depopulated.

A claim on the Santa Rosa Mine in what was later called Poverty Hollow was registered in 1709 by Don Juan de Ulibarrí. Ulibarrí said this claim was originally made by Governor Cubero (1696–1703), and that while the mine had been worked earlier, it was abandoned and he therefore had the right to own it. Cubero had probably confiscated the Santa Rosa Mine from Governor De Vargas, who he put under house arrest in 1696 and seized all of his property. It was illegal for governors to own mines while they were in office, so documents of ownership would not have been made. The 1696 takeover by Governor Cubero may explain why no record of Real de los Cerrillos has been found after de Vargas's terms as governor (1692–1696 and 1703–1704.)

In 1762, Tomás Antonio de Sena, *alcalde* (mayor) of Galisteo and Pecos Pueblos, claimed the Nuestra Señora de los Dolores mine grant, which is probably what is now called the Castilian Mine. This 1762 mine grant and a transfer of partial ownership of it in 1764, along with the 1709 grant, are the only Cerrillos mining grants from the 18th century that have survived in the New Mexico state archives.

The Cerrillos Hills may have helped finance the American Revolution. Spain was a major financier of the war and asked its colonies to contribute. While New Mexico had a barter economy at the time, there was some hard currency, probably the remains of the pesos left over from the development of Mina del Tiro Mine in the Cerrillos Hills. Some of those silver pesos might have ended up as New Mexico's contribution to the Revolution.

In 1816, the Village of Galisteo was established with 19 Hispano (people of Spanish/Mexican origin) families who settled near a permanent source of water not far from the ruins of the abandoned Tano Indian Pueblo of the same name.

In 1820, Mexico gained its independence from Spain, and trade to the east opened up along the Santa Fe Trail. In that same year, a significant gold strike was made on the north side of the Ortiz Mountains adjacent to the western side of the Galisteo Basin. These were placer deposits with gold dust, with some nuggets found in water-deposited soils, that had washed down from the adjacent mountains.

Within 10 years of the first placer discoveries, miners actively searching for gold in the mountains had established the Mina del Santo Niño Mine south of Oso Springs (Dolores) on the northeastern slopes of the Ortiz Mountains. This was the earliest underground gold lode mine in what is now the United States.

After the 1846–1848 war with Mexico, what is now most of Texas, New Mexico, Arizona, and California become territories of the United States. At this point, the quest for minerals really opened up, and there was extensive, though not especially successful, mining in the area.

In the spring of 1880, the railroad arrived, and the transcontinental route ran through the middle of the Galisteo Basin with stops at Cerrillos and Galisteo Junction, renamed Lamy, with the latter serving as the jumping-off place for those going on to Santa Fe because the grade was too steep for the mainline train to reach the capital.

The railroad brought people and commerce, which unfortunately caused considerable environmental degradation due to overgrazing and the railroad tracks cutting a floodplain in half, thus accelerating run-off, erosion, and watercourse down-cutting.

The archaeological riches of the area, while well known to Native Americans living in pueblos along the Rio Grande River, were first described for Europeans by anthropologist Adolph A. Bandelier, who journeyed south of Santa Fe across the "treeless plain" of Galisteo to visit the ruins of Galisteo and San Cristóbal Pueblos in 1882.

Between 1890 and 1910, the price of turquoise skyrocketed and then crashed. The American Turquoise Company, which was partially controlled by Tiffany & Company of New York, was actively exploiting turquoise deposits in the Cerrillos Hills that had been mined since prehistoric times. In the late 19th century, over 60 percent of US turquoise production was coming from the mines on Turquoise Hill, and turquoise was more valuable per carat than gold.

Gold, silver, and other metal mining did not prove to be especially successful. While there is plenty of gold in the region, there is very little of the water that is needed to effectively extract the gold from placer deposits and for processing ore. An experimental waterless electrostatic mechanism to separate gold dust from sand, developed and financed by Thomas Edison, was a complete failure.

In the 1970s, Occidental Minerals Corporation evaluated a copper deposit in the Cerrillos Hills estimated at 27 million tons. The plan was to set off underground blasts to break up the copper ore, inject sulfuric acid to dissolve out the copper metal, and pump up the copper/acid for processing. A test explosion was the largest non-nuclear blast at the time. Fortunately, this project was not found to be economically feasible.

This book contains a number of unique images, many of which appear here in print for the first time. These include the 1912 Nels C. Nelson photographs of archaeological work in the Galisteo Basin, as well as photographs taken in the summer of 1880 on a five-day trip to the Galisteo and Cerrillos Mining Districts by photographer George C. Bennett. He worked with W. Henry Brown (1844–1886) in the early 1880s out of a studio on the west side of Santa Fe Plaza. The family photographs of mining in the San Pedro Mountains are from Desri and Allen Pielhau of Golden, New Mexico, and are also unique images that have never been published before.

One

THE CERRILLOS HILLS

In his 1964 book *The Cerrillos, New Mexico Story*, Fr. Stanley Crocchiola states that "Legends of Cerrillos are more numerous than those of Santa Fe." Four incorrect myths are especially prominent: the railroad-mining town of Cerrillos is the same location as the Spanish Los Cerrillos; there was no Spanish mining in New Mexico until 1725; a significant amount of gold was found in the Cerrillos Hills; and the Spanish forced the Pueblo Indians to labor in the mines causing the 1680 Pueblo Revolt.

The Pueblo Indians started mining turquoise in the Cerrillos Hills around 700 AD, and by the 1200s, turquoise from Cerrillos was found throughout the Southwest. Turquoise is formed by a process called secondary mineralization, in which acidic solutions percolate and solidify in fractures in rock, a process quite different from the formation of precious and base metals.

Lead from the mines near Cerrillos Hills State Park was being used to make glazes for pottery as far away as Zuni Pueblo on the Arizona border by the early 1300s. Hundreds of tons of lead were mined in the 400 years of lead glaze pottery production by the pueblos. There may have been more than 40 Cerrillos lead mines, but only one has been studied by archaeologists.

In 1695, Governor de Vargas founded the Real de Los Cerrillos, the only official Spanish period mining camp in New Mexico. However, it was a mining boom in 1879 that brought the most activity to Cerrillos. In the 1880s, many small towns and camps sprang up in the Cerrillos Hills area. Territorial governor Lew Wallace, part owner of several Cerrillos mines, reportedly stayed in one such town called Carbonateville while he worked on the proofs of his Biblical epic *Ben-Hur: A Tale of the Christ*.

An overview of the history of the Town of Cerrillos is contained in Arcadia's 2013 book *The Turquoise Trail*. However, the town's importance to mining in the hills warrants some additional discussion. None of the photographs presented in this chapter are contained in the prior book.

A few turquoise mines survived into the early 20th century, while some limited turquoise mining continues to this day, primarily working with waste rock from prior mining.

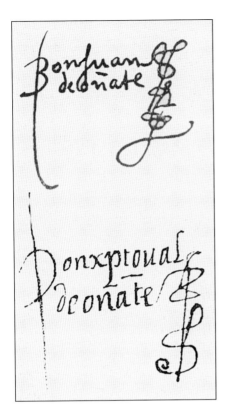

The Oñate family had become extremely rich from silver mining in Zacatecas, Mexico. A search for more silver was apparently a primary reason for Juan de Oñate's 1598 expedition to New Mexico; his signature is seen at left. Juan Cristóbal Oñate, Juan's son, was briefly the interim governor of New Mexico. His signature at left was recently discovered on a 1604 document; note that the modern version of "Xp" is "Ch," and "u" is "b." As described in the introduction, Tlaxcalan Native Americans who accompanied the Spaniards should be credited as the actual founders of Santa Fe. The sign below advertising the "oldest house" in Santa Fe is one of several near the intersection of de Vargas Street and Old Santa Fe Trail that recognize the Tlaxcalans' important role in the founding of New Mexico. (Both, ACS.)

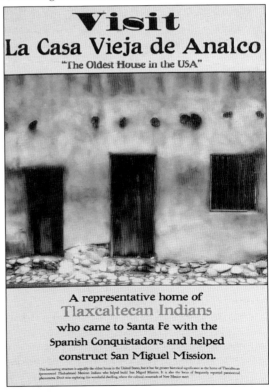

Visit
La Casa Vieja de Analco
"The Oldest House in the USA"

A representative home of
Tlaxcaltecan Indians
who came to Santa Fe with the
Spanish Conquistadors and helped
construct San Miguel Mission.

This fascinating structure is arguably the oldest house in the United States, but it has far greater historical significance as the home of Tlaxcaltecan (pronounced Tlachcaltecan) Mexican Indians who helped build San Miguel Mission. It is also the focus of frequently reported paranormal phenomena. Don't miss exploring this wonderful dwelling, where the cultural crossroads of New Mexico meet.

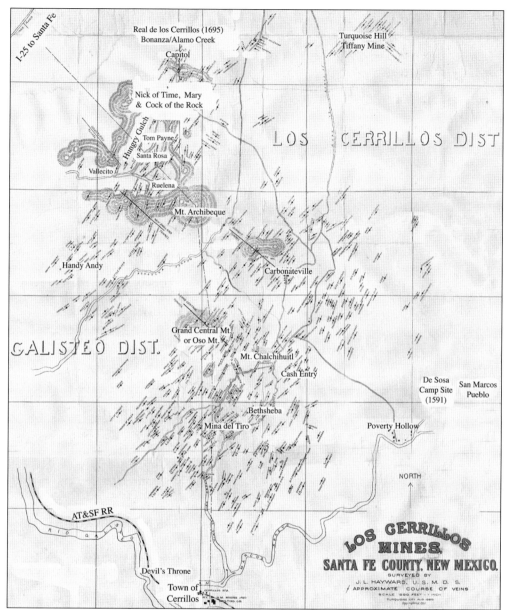

This 1880 map of the "Los Cerrillos Mines, Santa Fe County, New Mexico" was prepared by surveyor/mining engineer Jacob Lyman Hayward (born 1852), who was hired by the US government to map active mining claims in the Los Cerrillos and Galisteo Mining Districts. The map, along with an accompanying written report, describes a total of 436 mines, although ultimately there were over 1,000 mining claims in the two districts. The report notes that there are about 50 sites that appear to relate to Native American or Spanish mining activity. In 1880, parties wishing to reach the mines could do so by catching a daily stagecoach from the Grand Central Hotel in Santa Fe to Turquoise City, also known as Carbonateville (see page 26). Mining claims were delineated along a defined ore vein and were to be no more than 1,500 feet long by 100 feet wide and marked by stakes at each corner and at the discovery site. (ACS.)

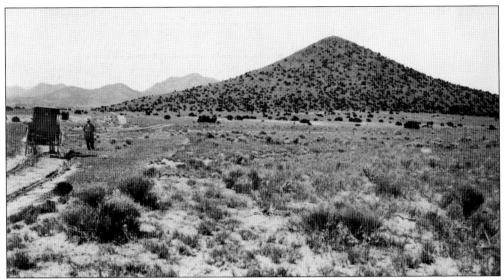

These two photographs from 1880 show the Cerrillos Hills looking southeast from east of the Interstate 25 off ramp at the La Cienega exit (271), a little less than five miles south of Santa Fe. The Los Cerrillos Mining District encompasses approximately 30 square miles and contains deposits of lead-silver, copper, turquoise, zinc, and minor amounts of gold. The conical hills are the remnants of 34-million-year-old volcanoes that pushed up through older sedimentary rocks, with near vertical veins of silver-lead sulfide (galena). Extensive drifts, such as tunnels, and shafts dug by Spanish miners, reached a depth of around 110 feet, below which the water table is found. Evidence of such deep mining was rediscovered in the 1800s in both the Mina del Tiro and Santa Rosa Mines. (Both, BB.)

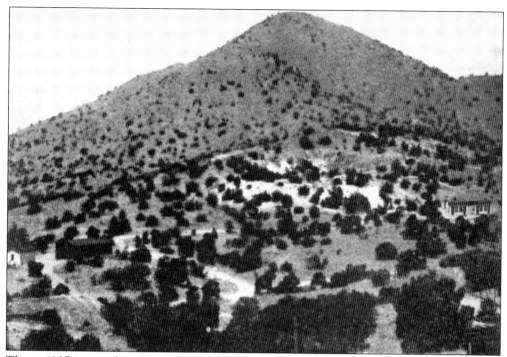

The c. 1905 image above looks west at Mt. Chalchuitl from the Cash Entry Mine, with Oso Mountain in the background. The lighter colored eastern pits from prehistoric mining are full of pinion trees. This is the location of the largest open pit Native American mine in the United States. The photograph below is an 1880 view from the top of Mt. Chalchuitl looking north. Mt. Chalchuitl is one of a few place names in New Mexico that derives from Nahuatl, the language of the Aztecs, as well as the Tlaxcalans who accompanied Oñate in 1598. It means "green stone" (turquoise). The Pueblo Indians started mining turquoise in the Cerrillos Hills as early as 750 AD, and by the 1100s, it was the major export of New Mexico, with separate mining camps (small pueblos) in the hills. There is a yet unproven theory that Cerrillos turquoise was the economic base for the development of Classic Chaco culture in northwestern New Mexico. (Both, BB.)

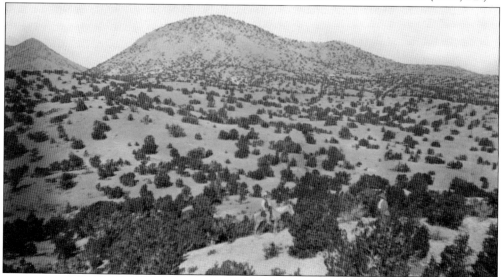

Based on pottery found associated with prehistoric mining activities, there appear to have been two major ancient periods of mining: one from about 1000–1200 and another from 1350 until the pueblo revolt in 1680. Intermittent turquoise mining by various Native groups continued into the 20th century. Native American cobbing piles (waste rock broken away from concentrations of turquoise) have been found adjacent to mines. In the 1990s, a collection of Casas Grandes pottery sherds from Mexico was stored in a shed near a turquoise mine north of the hills. This is mentioned to prevent a false conclusion of 14th-century Mexican turquoise mining in the area. The photograph at left overlooks the western pit of Mt. Chalchuitl, toward Cerro del Oso (Grand Central Mountain); the man in the foreground is sitting about 15 feet from the cross seen on the opposite page. Below is an image from inside the pit; the rider is thought to be Mike O'Neil. (Both, BB.)

In 1879, Maj. D.C. Hyde, in association with a group of New York investors, acquired mining claims that included the Chalchuitl pits. Hyde began commercial development on January 1, 1880, as the Grand Reserve Consolidated Gold and Silver Mining Company; as the name implies, the company was looking to mine gold and silver deposits rather than turquoise. At that time, turquoise had essentially no commercial value in Anglo society. These 1880 photographs show the west pit of Mt. Chalchuitl looking northeast. Note the cross erected by Hyde on top of the mountain. The man in the foreground is also in a number of others taken in 1880; it may be photographer George C. Bennett or his brother. The below photograph is looking northeast at the bottom of the prehistoric pit with a new shaft and windlass built to help Hyde sell stock. Note how nicely he cleared a circle around the shaft. (Both, BB.)

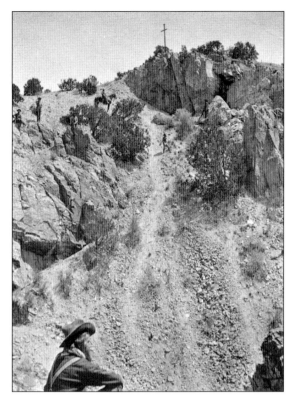

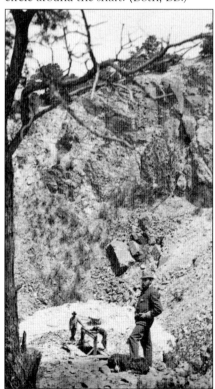

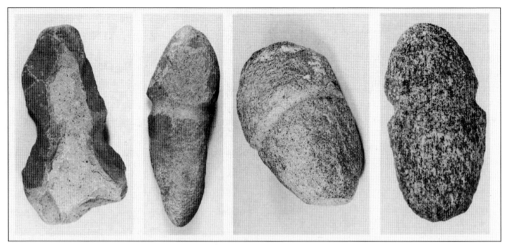

Stone tools, including grooved axes, mauls, picks, hand-held hammers, and anvils, were used by the Native Americans to work turquoise and lead mines. Occasionally, a non-utilized notched or grooved axe or maul has been found at a workshop area, indicating that workshops may have been used in the manufacture of mining tools. Refining areas located on the edge of the lead vein have also been found. The photograph above shows a collection of stone tools found in the Cerrillos Hills, while below is a reconstructed stone maul made by Todd Brown of Cerrillos. (Above, ACS; below, TPB.)

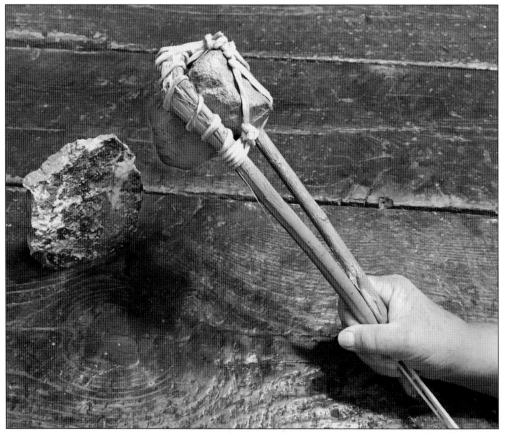

At right are, from left to right, geologist/ archaeologist Sharon K. Hull; author Homer E. Milford, New Mexico Bureau of Geology & Mineral Resources; and National Park Service archaeologist Joan Mathien examining a prehistoric turquoise mine. Turquoise rarely occurs in a discrete vein, as seen here, giving this mine more the look of a lead mine. Beginning about 1300, lead ore (galena) was used for making glaze paint for pottery. This was the first scientific exploration of a prehistoric and early historic mine of this type in the United States. Below, in 1972, Albuquerque Archaeological Society member Phyl Davis records and Dick Bice measures a prehistoric trench mine that was named the Bethsheba Mine in 1879. Pueblo Indians with stone hammers removed the least amount of rock possible to get to the ore vein. They did not need ladders, as they could climb out at the end of the vein or up the narrow slit formed by the mined-out vein. While a day's work with a stone hammer might remove only a pound or two of lead, over 400 years of working, a vein could yield hundreds of tons. (Both, AAS.)

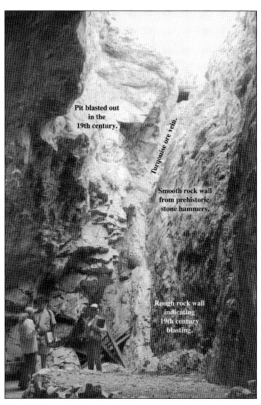

Pit blasted out in the 19th century.

Turquoise ore vein.

Smooth rock wall from prehistoric stone hammers.

Rough rock wall indicating 19th century blasting.

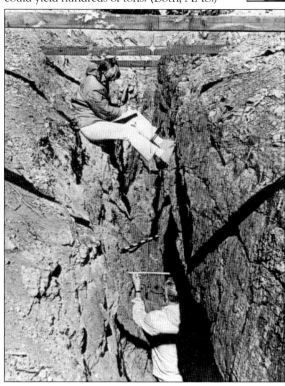

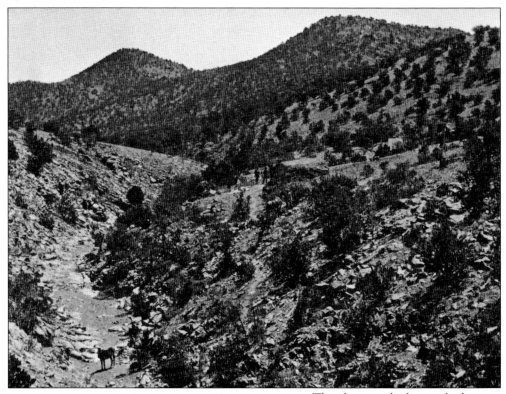

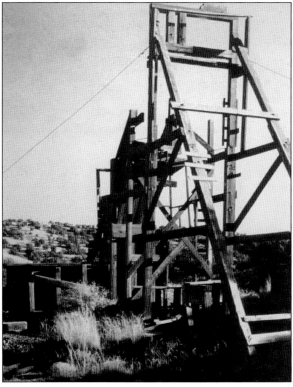

The photograph above is looking up Hungry Gulch in 1880. In this area are sites not only of prehistoric lead mining, but also sites that exhibit strong evidence of Spanish and Mexican period lead-silver mining. They contain ore deposits that were probably shown to members of the Rodriguez-Chamuscado Expedition in 1581. The image at left is a 1975 view of the remains of the World War II period head frame of the Mina del Tiro Mine. In 1857, a geologist was told by a member of the Delgado family who owned the mine (see opposite page) that his father had changed the name from the Saint Joseph Mine to the Mina del Tiro Mine in 1832. (Above, BB; left, ACM.)

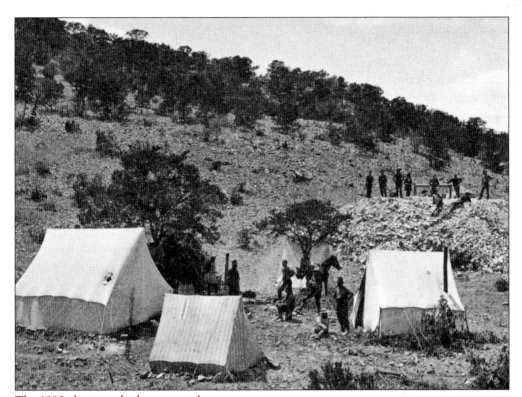

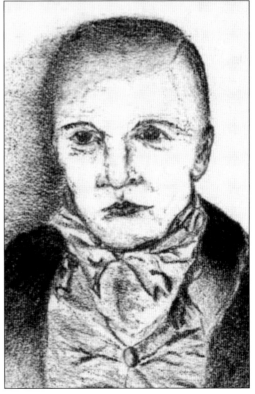

The 1880 photograph above was taken looking west at the Ruelina Mine in Hungry Gulch. It is a few thousand feet east of the Santa Rosa Mine that was originally owned by Governor Cubero (1694–1698) and reclaimed in 1709. Hungry Gulch galena is not found in Pueblo lead-glaze pottery, so it was not mined prior to Spanish colonization. It is probably one of the three Spanish-era silver-lead mines later reopened in 1830 by a group of Santa Fe businessmen, probably led by Manuel Salustiano Delgado (1792–1854). The group only mined for a few years, but built several smelters. The Delgado Ranch house was the site of the 1695 mining camp of Los Cerrillos on what is now called Bonanza Creek. Around 1841, the Delgado family moved their mining operations to New Placers. The drawing of Manuel Delgado at right is by an artist named Ionitza based on a photocopy of a tintype owned by Delgado's great granddaughter Margaret Delgado de Ortiz. (Above, BB; right, ACM.)

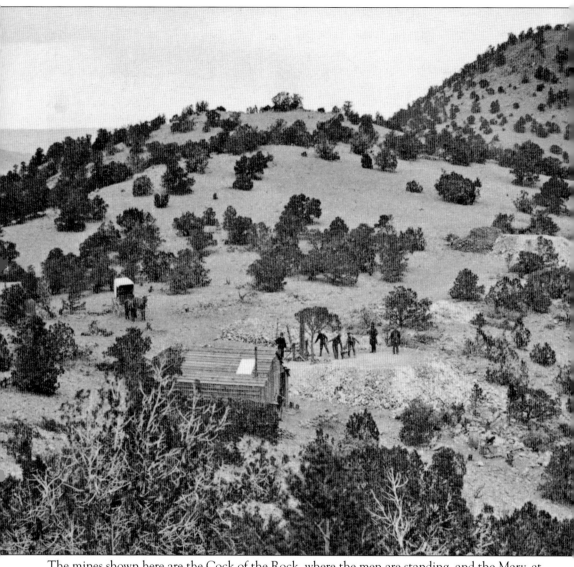

The mines shown here are the Cock of the Rock, where the men are standing, and the Mary, at the rock piles on the far right. Note that, as in the image on the previous page, they were using a hand-cranked windlass. Neither of these mines was worked much past the early 1880s, with the Cock of the Rock shaft going down 112 feet and the Mary about 60 feet. Both mines had old workings on them and are two of some fifty Spanish mines reported in the hills. The road from Bonanza to Hungry Gulch passed next to these two mines, and Santa Rosita Mountain is in the background. (BB.)

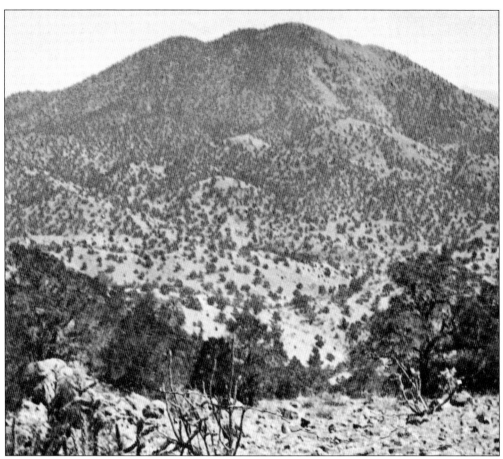

The view above is of Cerro del Oso (Hill of the Bear) from the saddle of Mt. Archibeque. Today, Cerro del Oso is more widely known as Grand Central Mountain. At right, miners investigate the surface for evidence of an ore vein. In the background is Mt. Archibeque. This name comes from Jean L'Archeveque (1672–1720), who at age 12 joined the 1684 La Salle expedition. He played a role in the killing of La Salle and, after his rescue (or capture) in Texas, was taken to Mexico City. In 1695, L'Archeveque was recruited in the silver mining town of Zacatecas to emigrate to New Mexico. This is the same year that Governor de Vargas reopened the Cerrillos silver and lead mines, so that could be the connection to Cerrillos. L'Archeveque's name was "Hispanicized" into Juan de Archibeque, and he has numerous descendants in New Mexico. It is not known if the mountain is named for him or one of his descendants. (Both, BB.)

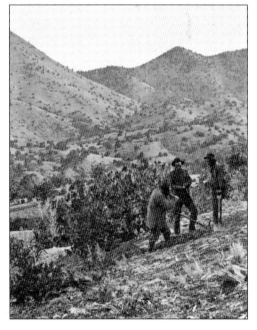

23

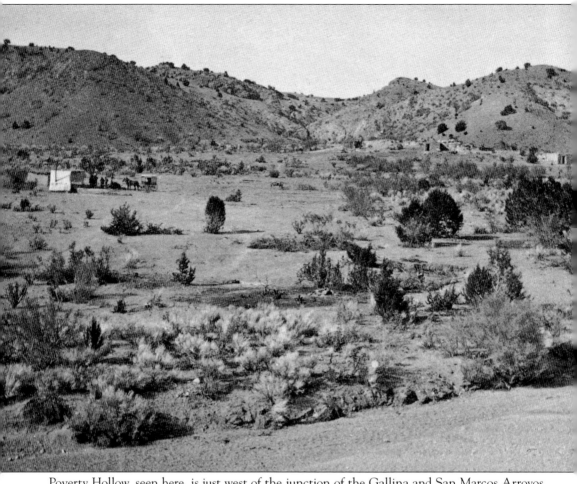

Poverty Hollow, seen here, is just west of the junction of the Gallina and San Marcos Arroyos on the north side of San Marcos Arroyo. The 1596 mining camp may have been near here; later, a reservoir was built at this location. An early 19th century placer miner claimed that the area contained nuggets of lead-silver and gold dust. The buildings in this 1880 photograph may be the ruins of pre-1880 dwellings associated with placer mining, although they are more likely connected with pre-1880 mining in the Cash Entry Mine area, this being the closest surface water source to the Cash Entry at the time. Note the photographer's wagon alongside the tent, which can also be seen on page 22. (BB.)

Bonanza, located just north of the Cerrillos Hills, is pictured here in 1880. It was built on the Los Cerrillos Land Grant just south of Alamo Creek, which was called Los Cerrillos Creek before 1879 and is often called Bonanza Creek, after the town. In this photograph are four houses for miners and the mill used for concentrating ore prior to smelting; the mill is the large building to the right with the smoke stacks. The photograph below shows sacks of ore from the mine about a mile to the south of the mill. There was a good water supply along with a church and a resident priest, as well as a post office from 1880 until 1883. The place was largely abandoned by 1890, although it had a small revival in the early 1900s when a small smelter was built there. (Both, BB.)

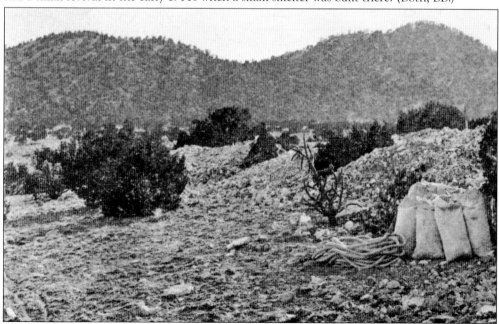

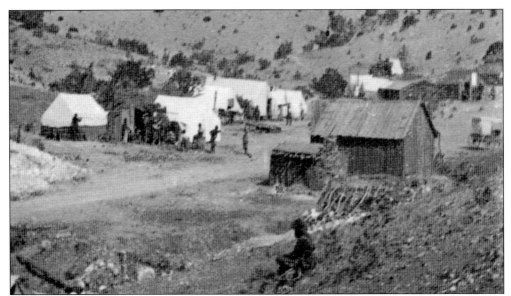

In January 1879, some Colorado miners founded a permanent settlement at what was then called Dimick's Camp, and Carbonateville a year later; an effort to name it Turquoise City failed. There were no wells in the town, and water was hauled from Alamo Creek for a dollar a barrel. The mines there were not successful, and the population shifted to the Cash Entry settlement about a mile to the south. These two 1880 photographs show almost all of the town of Carbonateville: the photograph above was taken from the southeast corner of town looking north, and the image below is looking west. The miners were all living in tents as they still had not found paying mines. The shed for the steam hoist of Dimick and Hart's Carbonate Lode Mine is visible at the top of the ridge below. This steam engine was one of the first in the district and was financed in part by the sale of interests in the mine to local dignitaries US Surveyor General J. Lyman Hayward and Santa Fe merchants Spiegelberg & Spiegelberg. (Both, BB.)

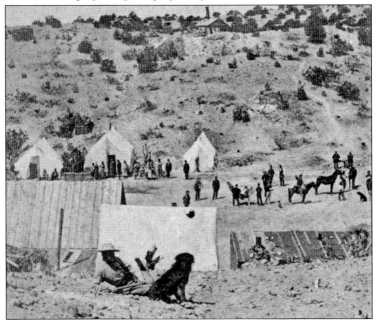

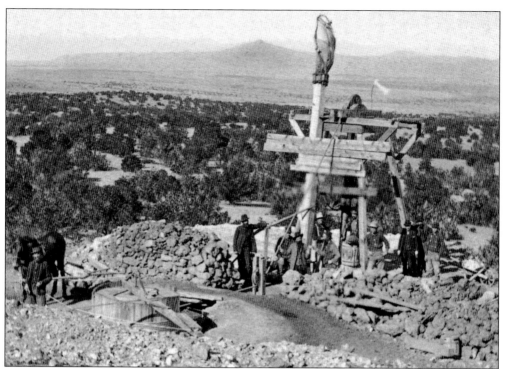

In New Spain and throughout Europe before the 20th century, a *malcate*, or horse whim, as seen here, was used mainly to hoist water out of the mines. Its rope-winding drum is above ground level, rather than below ground level like most US versions of the device. As seen here, it could hoist a full whisky barrel of ore as opposed to only a half-barrel as seen on page 34. The 120-foot depth of the Capitol Mine in 1880 required a horse whim. The perfectly vertical 100-foot-deep shaft that the Mina del Tiro is named for was dug in the 1770s to de-water that mine by a man named Francisco Diaz Moradillos. Tetilla Peak is in the distance, and beyond it is the gorge of the Rio Grande. The photograph below, also from 1880, shows a group of miners and prospectors in the Cerrillos Hills. (Both, BB.)

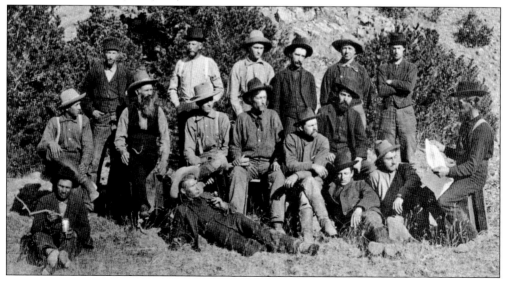

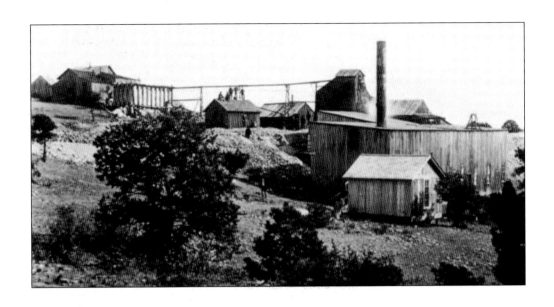

The Cash Entry Mine, seen in these two photographs, was the highest producing mine in the Cerrillos Hills. Significant underground workings began when the Boston–New Mexico Mining Company developed the property in 1880. Prior to its closing in 1915, thousands of tons of rich silver ore, with values in gold and copper, were extracted, with 4,500 tons of lead-zinc ore alone from 1890 to 1903. It reached a depth of 450 feet and about 250 gallons of water per minute was being pumped from the mine. "Cash Entry" describes the way the property was obtained from the US government by a simple cash purchase, as opposed to a mining claim or homestead. The law changed immediately after this purchase, so the owners must have been most pleased with themselves when they named the mine. Some ore mined in the mid-1880s was shipped to Wales in Great Britain for smelting before a mill was built locally. (Both, BB.)

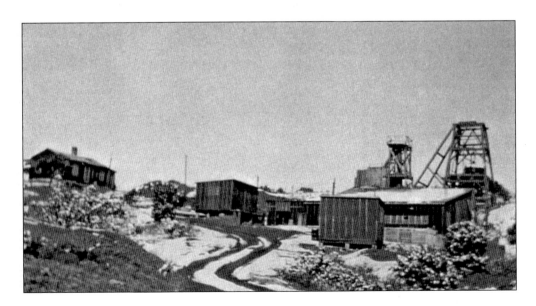

Above, a Spanish period silver/lead smelter is being excavated at San Marcos Pueblo. In 1998, author Homer E. Milford guided the construction of a working re-creation of such a smelter at El Rancho de las Golondrinas, a historic rancho and now living history museum near Santa Fe, . This smelter was based on instructions written by Gonzalo Gomez de Cervantes in 1599. Below are the remains of an actual Spanish smelter discovered near the ruins of Paako Pueblo about 30 miles south of Cerrillos. Unfortunately, it was on private land, and the homeowner destroyed it to make way for an expanded driveway. (Above, MAC; below SAC.)

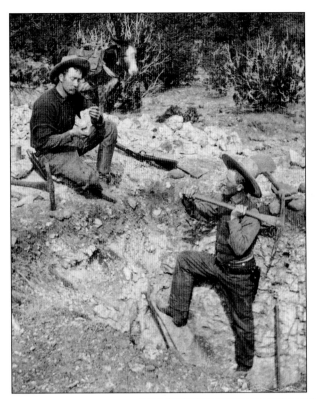

These 1880 photographs of the same two men, both taken by Bennett & Brown of Santa Fe as stereopticon slides, are labeled respectively "Strike it Rich" and "Pards in Camp." Though staged for the photographer, this is probably a reasonable representation of a temporary miner's camp. In the image below, note the gun belt with revolver hanging from the piñon tree and the wooden-handled shovel, two sledge hammers, and an iron pike leaned against the two pickaxes lodged into the ground. The repeating rifle is in the shelter between the two men. Though there is a coffee pot near the fire, the man on the right is pouring his drink from a bottle. (Both, BB.)

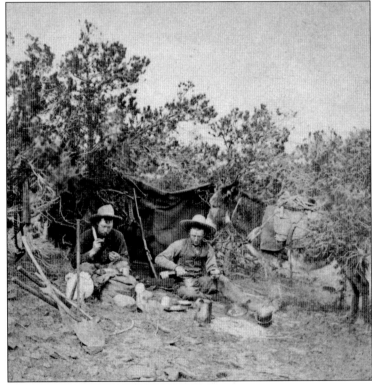

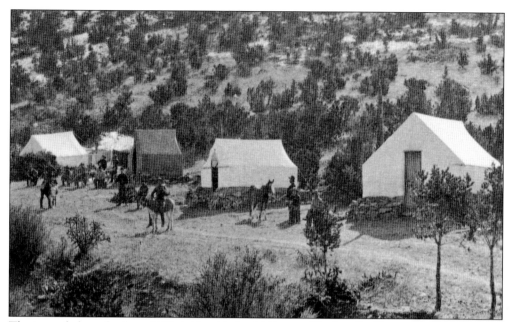

The image below, also from 1880, is identified as Vallecitos ("little valley"), a common place name in New Mexico. It shows a fancy miner's house. The wooden boxes stacked next to the house are probably from canned food, as most miners at the time still used black powder, which came in cans, rather than dynamite, which came in boxes. J.L. Hayward, who wrote the 1880 book promoting the Cerrillos Mining District, did so to help him sell stock in the many mines he had partial ownership of. He changed the names of many things to help in that effort. For instance, the Spanish Sierra del Oso, "Mountain of the Bear" sounded scary, so he changed it to Grand Central Mountain. He either did not own any claims in Vallecitos or disliked someone who did, so he changed its name to the derogatory Poverty Hollow, which actually had the richest silver mines in the Cerrillos Hills. Note how fancy its houses were compared to Carbonateville (see page 26). (Both, BB.)

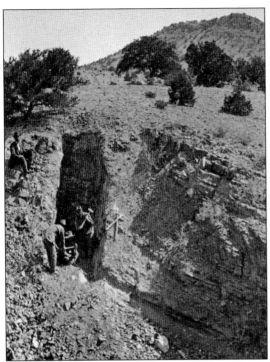

The 1880 photograph at left is of the Handy Andy Mine, one of numerous such diggings at the time, and was taken by George C. Bennett, perhaps because he and his brother owned it and thought a picture might help them sell it. The men in the trench are staging a demonstration of "double jacking," (two men hand drilling with sledge hammers). The image below, also from about 1880, is of the Homestake Mine in the west central area of the Cerrillos Hills; this galena and copper mine was located in 1879 by John W. Martin. The windlass (similar to the mechanism used to lower and raise a bucket of water in a well) was the most common device for moving materials into and out of vertical mine shafts. The man-powered windlass is practical to depths of 75 feet or more. In this case, two men are transporting a third man up or down the shaft, with a fourth (perhaps John Martin) observing. (Both, BB.)

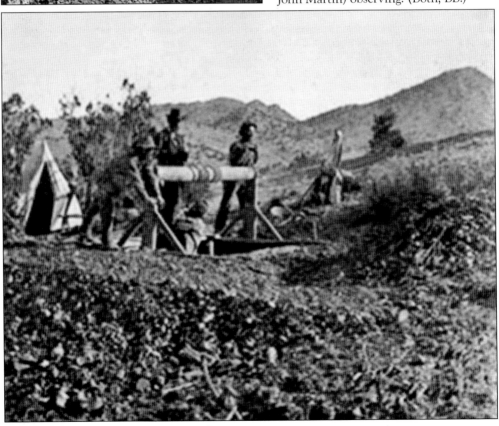

Both of these photographs are of the American Turquoise Company's Tiffany Mine, with the image at right from about 1900 and the one below of Herculano Montoya (1889–1981) at the mine in about 1938. Tiffany and Co. never made a claim in its own name, although much of the production of the Tiffany Mine was turned into jewelry by Tiffany. Recent surveys indicate that the Native Americans utilized the Tiffany pits on Turquoise Hill. Based on pottery sherds, the greatest early mining activities probably took place between 1375 and 1500. Commercial turquoise mining did not start until the late 1880s and essentially ended with the collapse of the turquoise market between 1909 and 1912. Turquoise mines in the Cerrillos hills have only been worked sporadically after 1915. (Right, NMG; below, BB.)

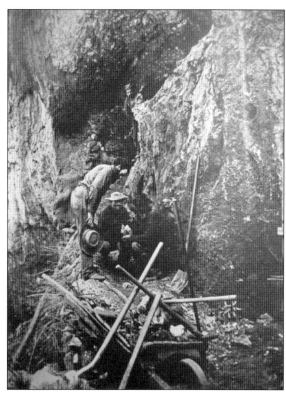

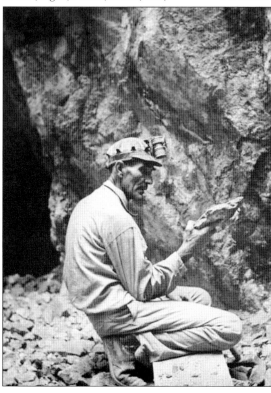

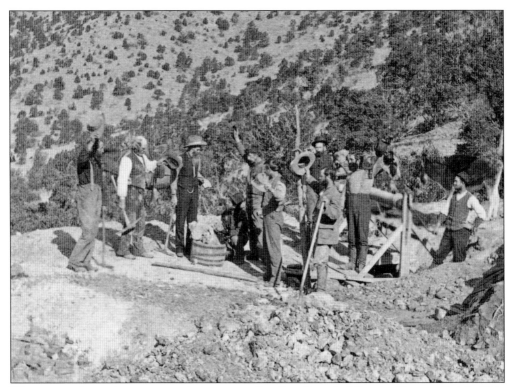

The miners shown here are examining ore at the Our Georgie Mine in Hungry Gulch. This mine's name was changed prior to 1900 to the Tom Payne Mine and was the last producing mine in the district, closing in 1957. The half bucket of ore, ostensibly pulled up by the hand-cranked windlass, (see page 33) was overfilled for the photograph. Underground mining at the site began as early as 1830 by a man named Alvarado. By 1945, its shaft went down to 310 feet. By 1912 the silver ore had run out, but from 1911 until it closed, it produced over 6,800 tons of lead/zinc ore. (Both, BB.)

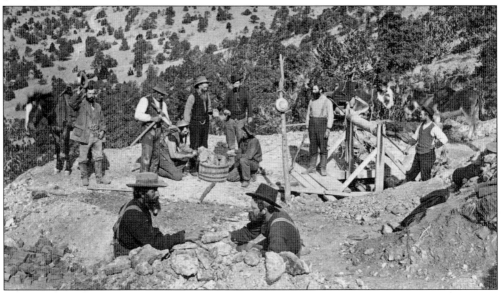

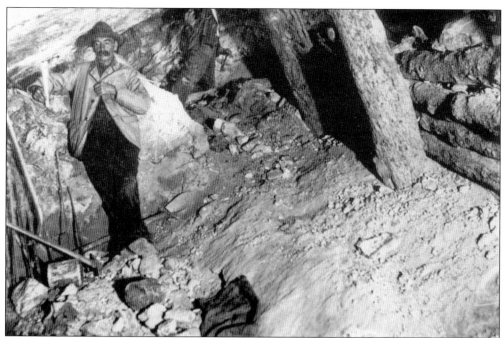

Both of these photographs are of the "underground" at an unidentified mine in the Cerrillos Hills. They are from the collection of the New Mexico Bureau of Geology & Mineral Resources archive in Socorro and appear to date from the late 19th century. They provide a good idea of what it was like being a miner at the time. Note the candles for light, hand-held hammers (called "jacks") for driving drills, and the tin buckets, probably for black powder. Miners would sometimes harden their hats with resin and linseed oil; while not as effective as a metal hard hat, they would provide some protection from small falling rocks. Such a hat is perhaps also being worn by the miner in the top photograph on page 33. (Above, NMG p-01781; below, NMG p-01780.)

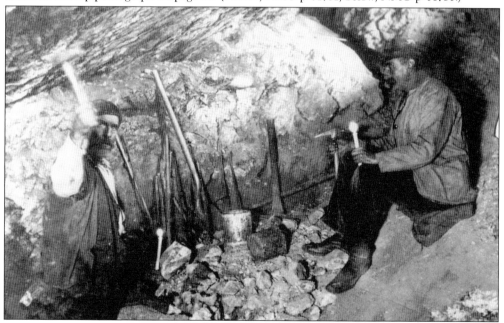

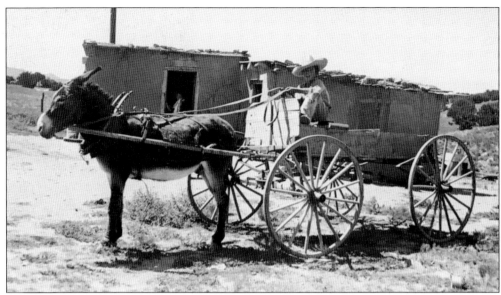

Before the railroad and the mining boom, life in the Cerrillos area was isolated, and it was difficult to get around. The photograph above shows a typical scene from a Hispanic farmstead in the Cerrillos area. In early 1879, when miners began arriving in the Cerrillos Hills in large numbers, they saw as a first task the need to set up mining districts and to decide by vote on the rules of conduct. The Los Cerrillos and Galisteo Mining Districts were both founded in March of that year. The men, many from Leadville, Colorado, all knew that riches bring out the worst in people, and it was therefore essential to establish mutually agreed-upon rules and regulations. In the following year, the Atchison, Topeka & Santa Fe (AT&SF) Railroad arrived, and Cerrillos was firmly connected with the outside world. Below is a group of surveyors ready to define lots in town, or more likely, mine claims in the hills. (Both, TPB.)

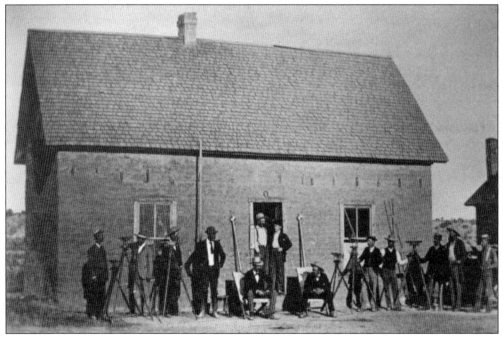

Henry Clay Green enlisted as a trooper in Troop E, 1st Regiment, US Cavalry Volunteers, also known as "the Rough Riders," on May 6, 1898. He died on July 1 from a bullet wound in the chest during the first charge up San Juan Hill, one of only three who died on the hill. He was educated at Kansas University and, after leaving school, followed mining. He was foreman of the Stephenson & Bennett Mine near Las Cruces, New Mexico, and at the time of the first call for volunteers to go to Cuba, he held a position at the Ortiz Mine near Cerrillos where he earned $3 per day. Buried first where he fell in Cuba, Green was later returned home to New Mexico for burial. He remains to this day in the Cerrillos Protestant Cemetery. Theodore Roosevelt later came to Cerrillos to pay his respects to Green's parents. The detail below of an 1898 painting by Frederick Remington, *Charge of the Rough Riders at San Juan Hill*, shows the moment of Green's death; Roosevelt is on the horse. (Right, SAC; below, USNA.)

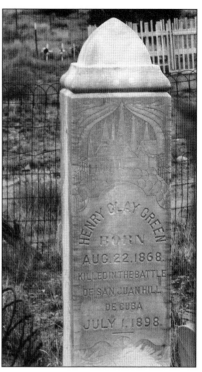

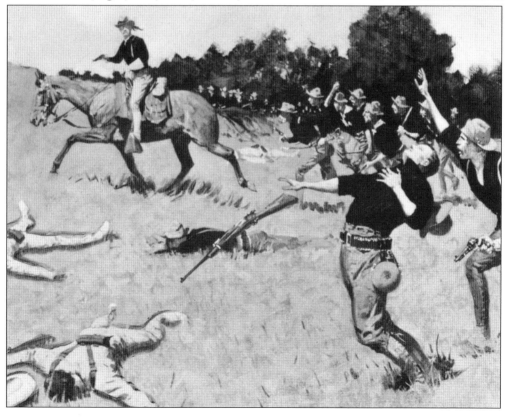

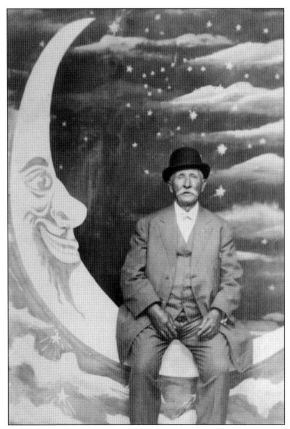

James Patrick McNulty (1849–1933) was a Leadville miner who first came to Cerrillos in 1881. For a while, he lived in San Pedro and Dolores, but from 1892 to 1920, he was the manager of the American Turquoise Company and its successor mines on Turquoise Hill. He is pictured at left in his later years sitting on the moon, and below in front of his house with his second wife, Emma Hawley (1867–1954). McNulty had three children, Agnes, Frances "Fannie," and Eddy. Eddy obtained a couple of claims on Turquoise Hill. Fannie kept the American Turquoise Company records, an important historic resource for later researchers, and was a longtime school teacher in Cerrillos. (Both, TPB.)

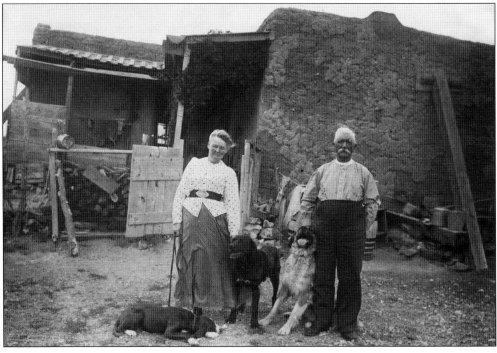

Intense summer rains in New Mexico can sometimes create havoc. These photographs are of flooding on the Galisteo River in the summer of 1926. Many roads, and the railroad bridge seen above on the AT&SF main line, were washed out. This bridge was soon replaced, and the First Street bridge was replaced in 1928, only to wash out again in 1955. The subsequent highway relocation and bridge replacement east of the town eliminated traffic from First Street through the town. (Both, TPB.)

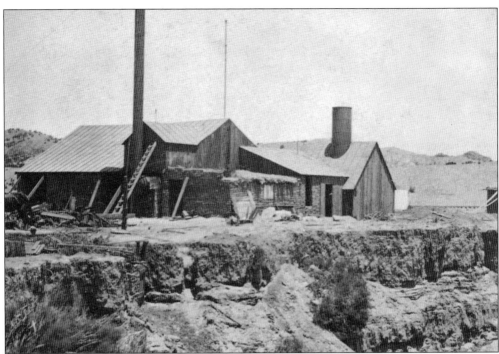

The photograph above looks north at the New York and New Mexico Mining Company smelter in 1880, the first large scale commercial smelter in the region. It was taken from about 500 feet east of First Street near where the later 20th-century road enters the town. At the time, there was an ox bow in the Galisteo River that was later filled in. The last smelter in Cerrillos, seen below, processed lead ore from Madgalena, New Mexico, about 150 miles south of Cerrillos. At its peak in 1913, this smelter employed 100 men, but by 1918, it was closed. (Above, MAC; below, NMBM sh-00656.)

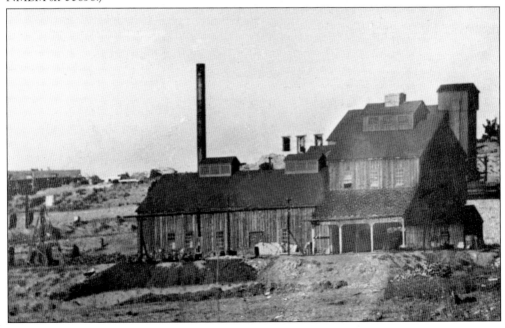

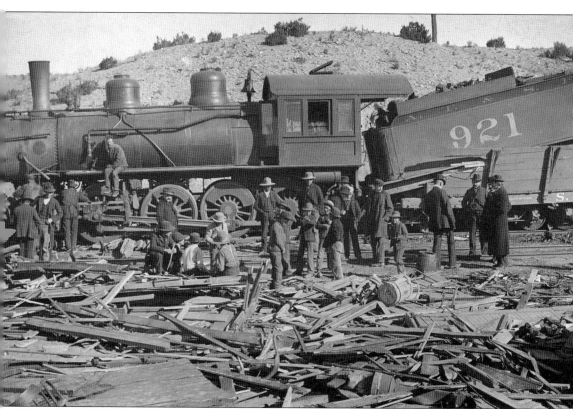

This photograph is labeled as a train wreck from the 1890s at a location near Cerrillos. However, it is clearly not a train wreck, but rather, an explosion. A building has been blown to smithereens and the coal tender partially upended, yet the locomotive shows no damage at all. There is a 2-8-0 class locomotive of the same type on display at the mining museum in Madrid, a few miles south of Cerrillos. The Madrid locomotive was built by the Richmond Locomotive Works in 1900. (TPB.)

The south side of the Devil's Throne has changed very little since this photograph was taken only months after the arrival of the AT&SF. This photograph was taken a short distance west of Cerrillos on the Waldo Road. A 200-foot-high chunk of intrusive igneous rock called diorite is well known for having had a piece blown out of it in 1939. Using 28,000 pounds of explosives, 150,000 tons of the Devil's Throne were reduced to two-inch pieces for use as railroad track ballast. It took a full two years after development began on this rail line for a proper station complex to be built. In the mid-20th century, with the demise of steam trains and the abandonment of coal for heating, the trains no longer stopped at Cerrillos. But those railroad buildings were built to last, and portions of this old Cerrillos depot building are still in use today in the city of Santa Fe and, as seen here, as a private house in the town of McIntosh, about 60 miles south of Cerrillos. (Left, ACM; below, SAC.)

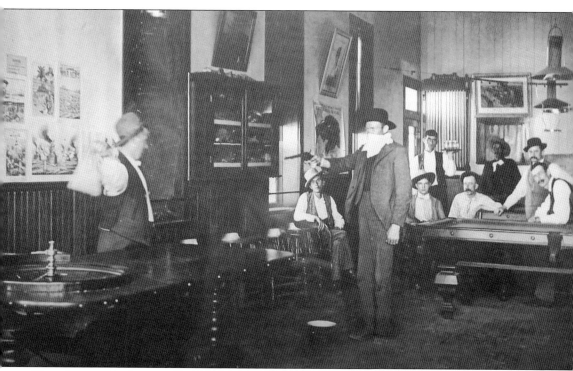

This photograph of a staged holdup was used as the advertising poster image for the 1982 annual conference of the Historical Society of New Mexico and is attributed to Harry T. Yontz (1866–1936), an Albuquerque jeweler and photographer. The photograph is dated 1899 and is believed to have been taken at the Tiffany Saloon in Cerrillos. This is perhaps apocryphal, as the well-known Tiffany Saloon and Restaurant did not open until 1962 and was destroyed by fire in an unsuccessful effort for the insurance money in 1977. Perhaps it was another Tiffany Saloon. In 1880, there were said to be 26 saloons in town, although that number was down to five by 1891. (TPB.)

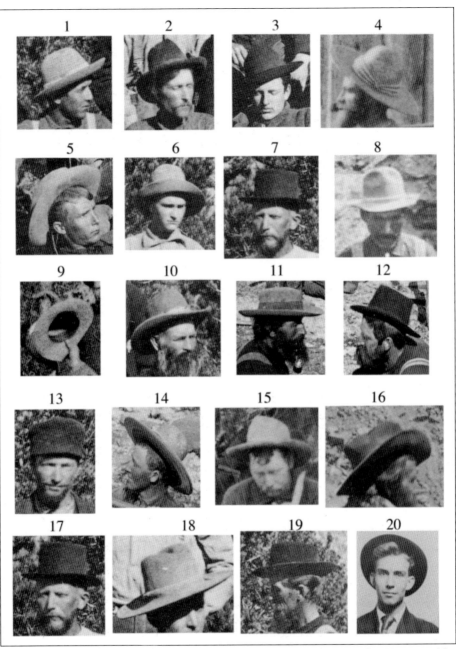

All of these photographs were taken in the Cerrillos Hills in the spring of 1880 except No. 20, which shows author Paul Secord's grandfather in Cerrillos in 1912. Many of the men were miners who likely had recently come to New Mexico from Leadville seeking better paying mines. Stuart Dunlap and Bill Sisk of the Man's Hat Shop in Albuquerque had the following observations: "By today's standards most of the hats are too small . . . the band on No. 4 must have been made by his wife or sweetheart . . . No. 6 just doesn't care about his headwear; Nos. 7, 12, and 17 are clearly machine production hats from back East; No. 11 paid special attention to the shape of the brim of his hat, which is considerably more dapper than most of the others; and No. 13 is a cap typically associated with Europeans." (Nos. 1–19, BB; No. 20, SAC.)

Two

THE GALISTEO BASIN

This chapter looks at landscapes across the Galisteo Basin, along with Hispanic and Anglo settlements found there. Native American occupation of the area is discussed in detail in chapter four.

The greater Galisteo Basin is approximately 730 square miles, located 25 miles southeast of the city of Santa Fe. This area is defined as the Rio Galisteo drainage, as bounded by the uplands of Los Cerrillos Hills on the north, and the Ortiz and San Pedro Mountains on the south (see map on page 2).

The most important town in the central part of the Galisteo Basin is Galisteo. Galisteo is first mentioned as a large inhabited pueblo by the 1580–1581 Fray Rodríguez/Chamuscado expedition; they were looking for silver as much as they were looking for souls to save.

The town of Galisteo was founded in the early 19th century when petitioners told the governor that they needed the land to support their families and that their presence would help provide protection against hostile Ute, Comanche, and Apache Indians who frequently raided from the plains to the east into this area.

Author, wildlife artist, and one of the founders of the Boy Scouts of America Ernest Thompson Seton (1860–1946) established his home and youth training center in the northern part of the Galisteo Basin in the early 1930s.

Both the Atchison, Topeka, & Santa Fe and the Southern Pacific (SP) rail lines reached New Mexico by 1880, and by 1900, the major link between southern Colorado and El Paso, Texas, was via the AT&SF to Albuquerque and down the Rio Grande Valley, passing through the recently established town of Cerrillos. The AT&SF bisects the greater Galisteo Basin, mostly following the north side of Galisteo Creek. The arrival of the railroad to the region was a major event, linking the remote territory of New Mexico with the industrial centers of the east and putting an end to the primary importance held by the centuries-old north-south Camino Real.

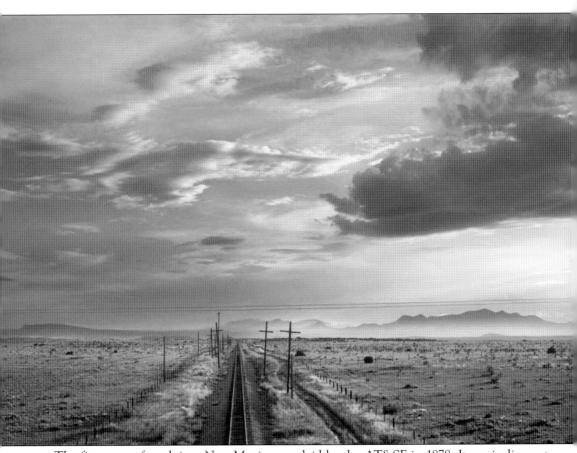

The first span of track into New Mexico was laid by the AT&SF in 1878. Its main line cut diagonally across the Galisteo Basin, and within 30 months, there were over 1,000 miles of rail line in the territory. Travelers heading to Santa Fe disembarked at Lamy about 10 miles from town because the grade was too steep for a mainline train to reach Santa Fe. This view across the flat plain looks just as Bandelier saw it in 1882. There were several coaling/water stops in the Galisteo Basin, including Kennedy, Ortiz, and Cerrillos (see page 97). (GM.)

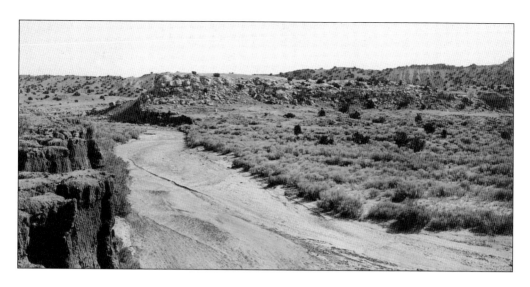

These two photographs, both taken in 1912 by Nels Nelson, show the north-central landscape of the Galisteo Basin in the vicinity of the current town of Galisteo. The low, grass-covered mounds are the remains of the large prehistoric pueblo of Galisteo (see page 112). The Rio Galisteo is clearly visible and is one of the few usually permanent watercourses in the region. It originates from several drainages flowing out of the Sangre de Cristo Mountains northeast of Santa Fe that join together near the town of Galisteo and, from there, go west for about 30 miles to the Rio Grande. Because of its location between mountain ranges and connecting the Rio Grande Valley with the Great Plains, the Galisteo River was an important route both prehistorically and historically. (Above, AMNH No. 305; below, AMNH No. 691/692.)

While the basin's landscape may appear nearly devoid of human activity, humans have left their mark everywhere upon closer examination. The photograph above is of an enigmatic alignment of upright sandstone slabs that cross an entire mesa near San Cristóbal Pueblo. Nelson thought they were "too large and formal to be (Hispanic) corrals." Perhaps they mark a boundary to the pueblo for outsiders. The photograph below is also near San Cristóbal Pueblo, with Nelson's camp in the foreground and the remains of the 17th-century mission church in the middle ground to the right. The road through this area looks about the same today. (Above, AMNH No. 189; below, AMNH No. 100.)

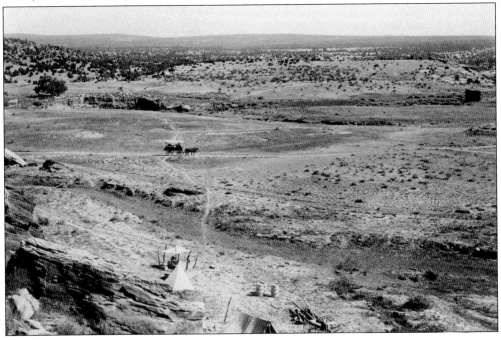

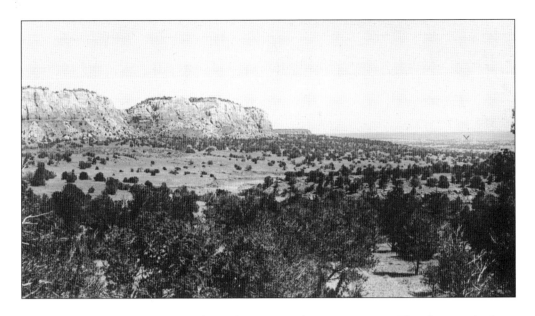

Both of these images look across the Galisteo Basin from west to east. The photograph above shows sandstone cliffs, the remnants of ancient seabeds and deltas that have eroded into a classic New Mexico mesa and valley landscape. The "X" in the middle ground to the right denotes the location of Pueblo Largo. Running diagonally from right to left in the image below is the Galisteo Dike, a volcanic extrusion of fine-grained black basalt. The dike is part of another basalt outcrop formation called El Creston and is also referred to as Comanche Gap; it contains some of the best-preserved and most graphic rock art in North America (see pages 125–126). (Above, AMNH, No. 212/213; below, AMNH No. 269.)

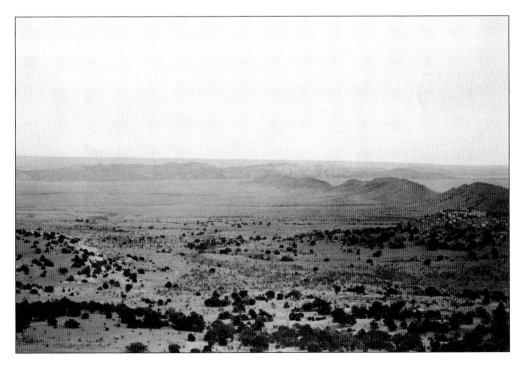

This small settlement is typical of Hispanic ranching and agricultural communities. This was probably along the banks of the Galisteo River several miles east of where today the river crosses Interstate 25. The adobe houses and chapel are characteristic features of New Mexico Hispanic villages. (AMNH, No. 726.)

The Galisteo group of the Tanos Indian Nation occupied this area until the latter part of the eighteenth century. Ruins of two important pueblos, San Lazaro and San Cristobal may still be seen. Espejo (1583), and Oñate (1598), were among early Spanish conquistadores to visit these pueblos.

Bainbridge Bunting became a faculty member of the University of New Mexico in 1948, where he taught architectural history until he retired in 1979. Here, he is pictured with his wife in the early 1950s on a reconnaissance survey to Galisteo. Bunting wrote numerous articles and three books on the architecture of New Mexico and managed the Historic American Building Survey during his tenure at UNM. He and his students recorded numerous buildings in the state. Below is a restaurant incorporated into the Ortiz House (see pages 60–64). (Both, CSWR.)

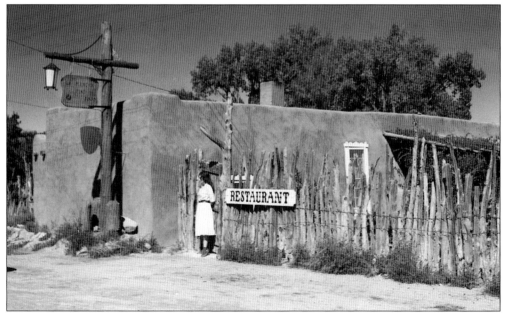

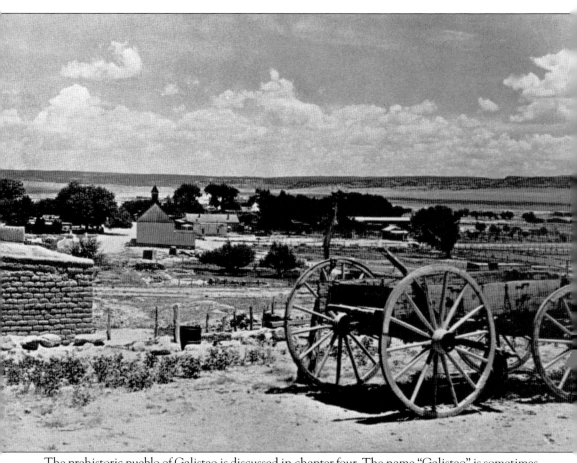

The prehistoric pueblo of Galisteo is discussed in chapter four. The name "Galisteo" is sometimes said to be an old term for a native of Galicia, Spain. A Franciscan mission established between 1617 and 1629 was destroyed during the Pueblo revolt of 1680. The deserted pueblo of Galisteo was reestablished in 1706 by Gov. Cuevo y Valdez, but in 1794, it was once again abandoned because of drought, Comanche raids, and smallpox. In February 1814, Felipe Matias and Pedro Sandoval, along with Jose Luis Lovato and Julian Lucero, petitioned Gov. Alberto Maynez for a tract of land encompassing the old pueblo site. They established ranches in the area as well as the town of Galisteo at its present location. After long and complex legal battles, land claims by the inhabitants of Galisteo were finally settled in 1927. This photograph shows the town in 1890. (CSWR.)

Above is the entrance to the Galisteo cemetery photographed by one of Bainbridge Bunting's students in the 1950s. This is a most elaborate entranceway for a cemetery, which would typically have a much smaller gate. The earliest graves here appear to date from the early 19th century. Below is a typical 18th/19th-century adobe. This house started out with plain adobe walls with no trim, but Americans in the 1850s introduced the simplified Greek Revival detail, as seen by the window frames and brick cap on the rooftop. This cap helped keep the wall from eroding and is characteristic of the 19th-century Territorial style. (Above, ACS; below, CSWR.)

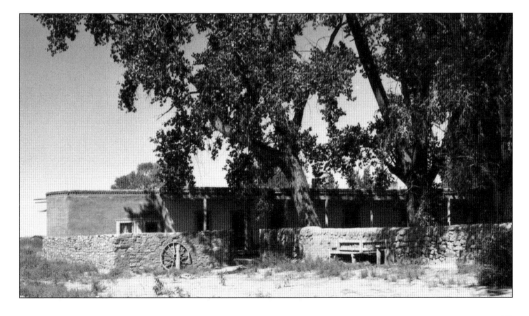

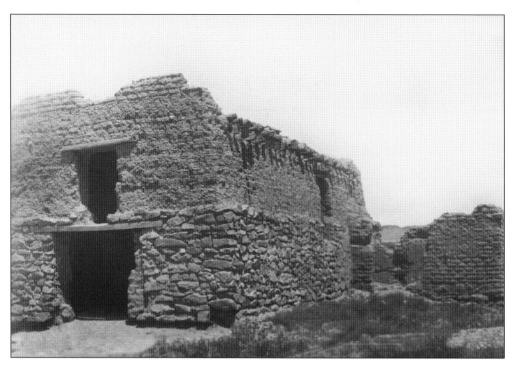

Above are the ruins of the 1706 church at Galisteo called *Nuestra Senora de los Remedios*, or "Our Lady of the Remedies," which was built to serve about 150 Hispanic settlers. Below is the "new church" built in 1884 on the same site as the 1706 church. It is essentially a reconstruction of the previous building, built on the same footprint as the earlier structure. This photograph was taken in the early 20th century. (Both, CSWR.)

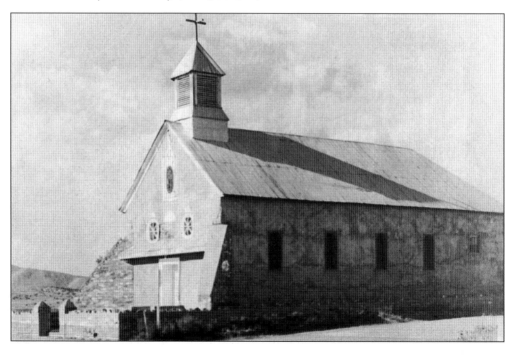

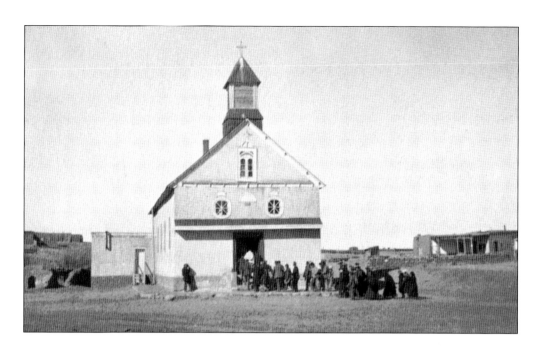

Here are two more images showing the 1884 church. The photograph above shows town residents entering the church for Sunday morning services. This looks to have been taken soon after the building was completed. The high-pitched roof and prominent steeple are characteristic of the French provincial architecture favored in the homeland of Jean-Baptiste Lamy. Lamy was bishop, and later archbishop, of New Mexico from 1850 until 1885. The photograph below from the late 19th century shows the new bridge crossing Galisteo Creek, with the church in the background. (Both, CSWR.)

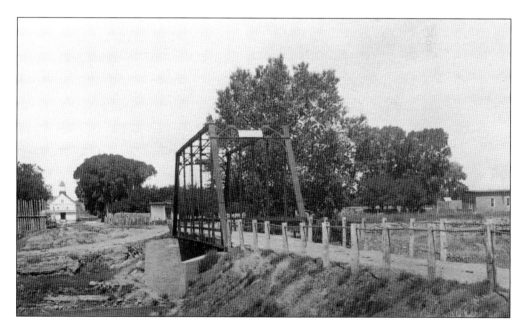

Cristóbal Maria de Larrañaga (1758–1851) came to New Mexico as a military surgeon and brought smallpox vaccinations to New Mexico in 1804, saving thousands of lives. (SAC.)

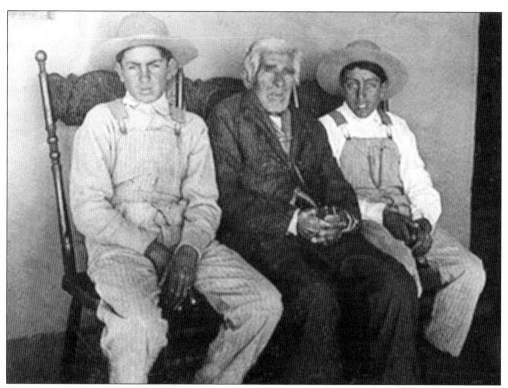

For many generations, the Larrañaga family has made a significant contribution in New Mexico. These photographs of Larrañaga family members were both taken in Galisteo. Above is Juan Bautista Larrañaga (born 1839), Cristóbal's grandson, who was born in Galisteo, with sons Pedro on left and Mariano "Memo" on the right. At right is Juan's son Manuel (also known as "Memo") Larrañaga (born 1864), with his wife, Cleofas Chávez Ramírez, and their children. The Larrañaga family is closely intertwined with the Pino and Ortiz families of Galisteo. (Both, CSWR.)

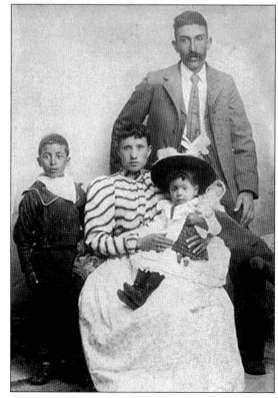

The Montoya family was one of the earliest Hispanic families in Galisteo. These photographs of the Montoya house were taken by Bainbridge Bunting students in the early 1960s and unfortunately have no documentation. However, the house's detail is an excellent example of the Territorial style described on page 53. The front door is an especially elaborate expression of this style. The turned columns supporting the porch are a striking contrast to the rough columns of the Lucero house on the opposite page. (Both, NMSA.)

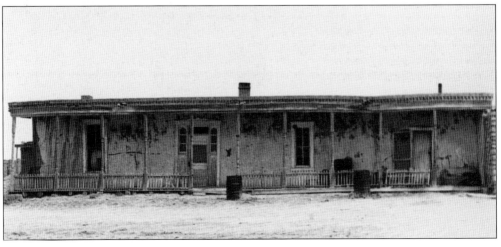

The Lucero house was documented by the Historic American Building Survey. Said to be constructed in the 1880s, it has some Territorial features such as Greek Revival window frames, but the rough porch supports suggest an earlier date. This house may have belonged to Julian Lucero, one of the town's founders during the early 19th century resettlement and a signer of the petition seeking a land grant in 1814. (Both, HABS.)

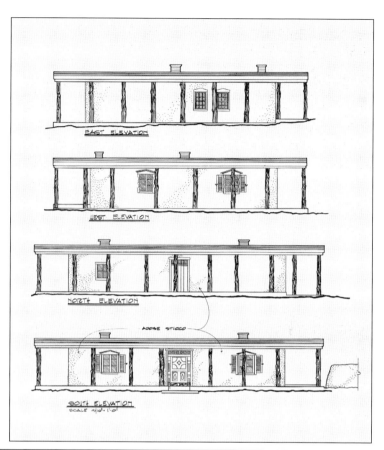

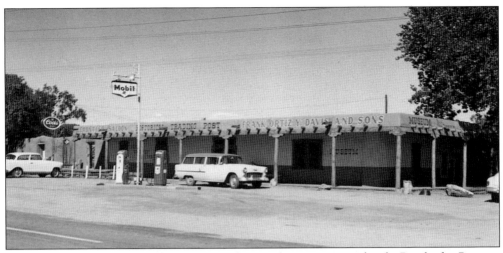

All of the photographs of the Ortiz house on the next few pages were taken by Bainbridge Bunting or his students. The Ortiz family has been prominent in Galisteo for generations. In the 1840s, Juan Ortiz II (1851–1929), who at the time lived in the mining town of Dolores (see pages 98–102), applied a for Galisteo land grant twice and was rejected. At his death in 1865, his widow, son, and daughter moved to Galisteo and lived in "the Hacienda," now on the corner of Interstate 41 and Via La Puente. Jose Ortiz (1874–1951) opened a successful mercantile in Galisteo and married twice, both times to daughters of Nicolas Pino, thus beginning the Ortiz y Pino lineage. The family compound was the center of social life and headquarters for a large sheep ranch. It also served as a stage stop between El Paso and Santa Fe. (Both, CSWR.)

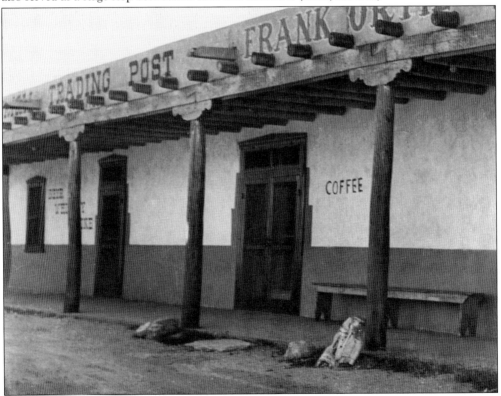

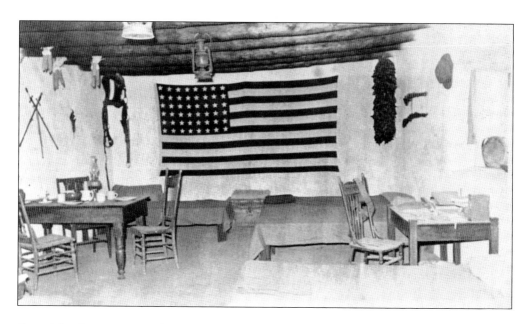

Part of the Ortiz compound may date to the early 18th century when it served as a dance hall/casino and trading post. In 1821, it was a military post where Mexican and later US soldiers were billeted. After being acquired by the Ortiz y Pino family, the buildings were expanded to include an earlier residence as well as a store, cantina, and wool warehouse. In later years, as seen on the following pages, in addition to being the family residence, it contained an herb shop, restaurant, gas station, and museum operated by Jose's son Frank Ortiz y Davis and later by his grandson Jose Ortiz y Pino. The room seen here in the museum wing is fitted out to look as it did when soldiers stayed in the compound. (Both, CSWR.)

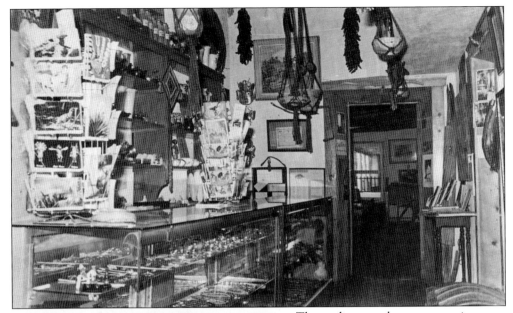

The trading post became a tourist trap of the best kind. In addition to postcards and inexpensive jewelry, there was a multiplicity of relics that the Ortiz family had gathered over the years. They included religious statues, called *santos*, said to be up to 200 years old, along with a child's coffin with a glass viewing plate and priest's vestments. Roadside attractions of this type are mostly long gone, bypassed by the interstate and given over to estate sales as family holdings changed hands. (Both, CSWR.)

Here is a bit more of the store and a peek into the family living quarters as they were in the 19th century. The Ortiz family has a number of distinguished members: Antonio Ortiz was the last Spanish priest at the Juarez Mission, Col. Miguel E. Pino served with the 1st Regiment New Mexican Volunteers in the 1860s, Don Nicolas Pino was a justice of the peace, and several family members served in the New Mexico state legislature, where Concha Ortiz y Pino de Kleven was the nation's first woman majority whip in a legislative body, from 1944 to 1948. (Both, CSWR.)

The Ortiz store included a wide selection of medicinal herbs. Above are various items used to prepare and store herbs, while the image below shows herbs hanging from the ceiling rafters to dry. The Hispanic world has a long tradition with herbal medicines, with the uses of many plants tracing back to indigenous peoples, especially from Mexico. The oldest herbal manuscript from the Americas is a translation of an Aztec text that dates to 1512. (Both, CSWR.)

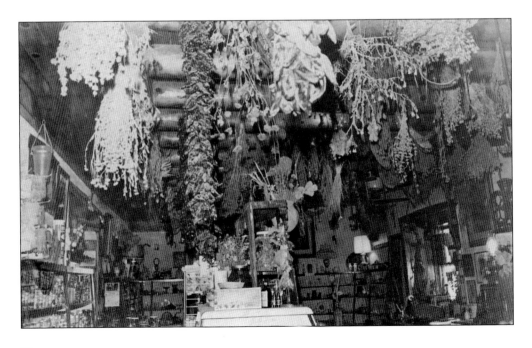

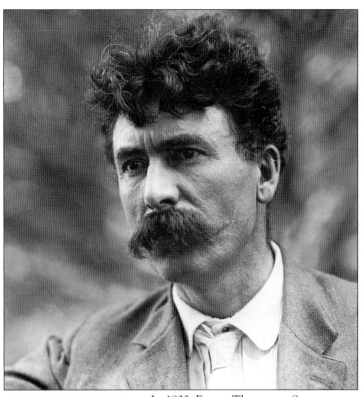

In 1933, Ernest Thompson Seton (1860–1946) purchased 100 acres on the north edge of the Galisteo Basin. Over the years, the initial tract of land grew to 2,500 acres and contained his home, Seton Castle, and various ancillary structures called Seton Village. Seton is perhaps best known for his wildlife art. Called the "Black Wolf," he won many awards as an illustrator and naturalist and was a champion of Native American rights. (Both, NMSA.)

At Seton Village, Ernest Thompson Seton ran a training camp for youth leaders. The castle, shown here, was designed and built by Seton. It was a 6,900-square-foot, two-story building with a flat roof and roughhewn stone wall exterior. The interior had oak floors and plaster walls with ceilings supported by log rafters. (Both, NRHP.)

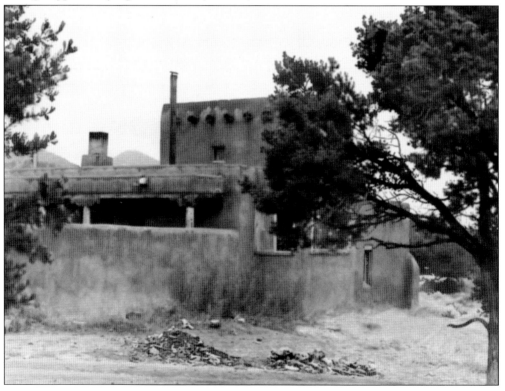

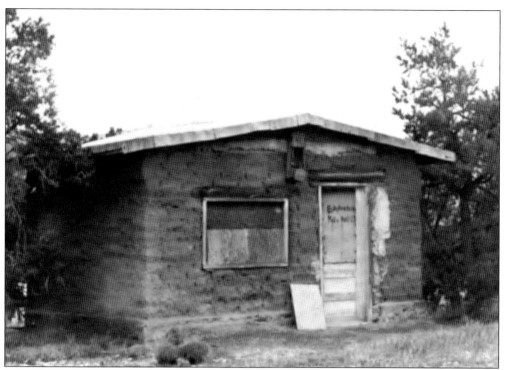

The railroad car and small adobe structure pictured here housed the Seton Village Press, set up by Maurice and Marceil Taylor in 1938. The press closed in 1943 due to World War II, after publishing 24 titles. Unfortunately, the castle burned during restoration in 2005, but the site has been preserved as a contemplative garden maintained by the Academy for the Love of Learning. Fortunately, all of Seton's artwork, manuscripts, and books had been removed for storage before renovation and are now housed at the Seton Memorial Library and Museum at the Philmont Scout Ranch in northern New Mexico. (Both, NRHP.)

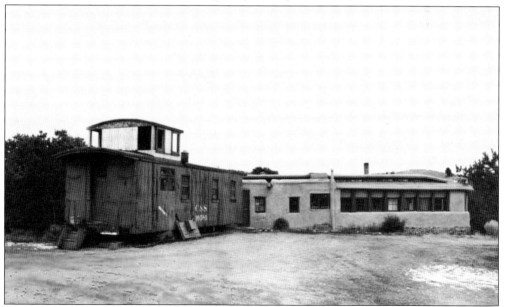

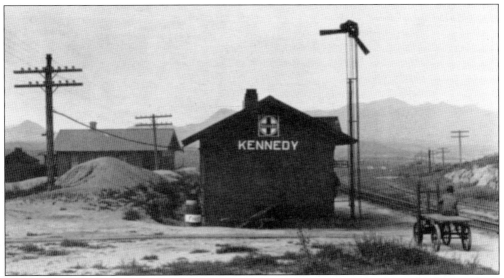

The c. 1907 photograph above is of the depot at Kennedy, about two miles west of Galisteo, where the old New Mexico Central Railroad (NMC) called the "Frijoles Line," crossed the AT&SF. Kennedy was named after Arthur Kennedy, an NMC official. The last run of the NMC was in 1944 from Estancia to Willard. The depot building serves today as the activities center for the community of El Dorado, but the "Kennedy" name has been painted over with "El Dorado." The image below is of Rogersville, four miles southwest of Cerrillos. Rogersville was named for William C. Rogers, who, after the demise of Carbonateville, became involved in mining coal there. Rogers was forced to leave in 1896 after mining in Madrid just a few miles south became active and essentially eliminated his market for coal. There was a spur to the community from the Santa Fe Railroad mainline. (Both, TPB.)

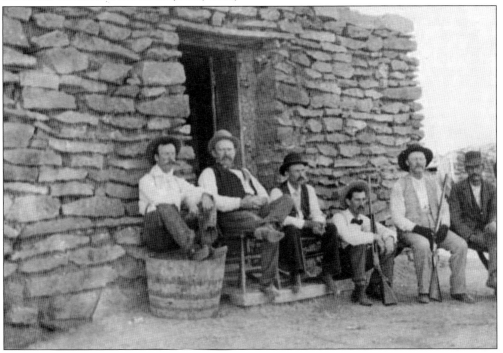

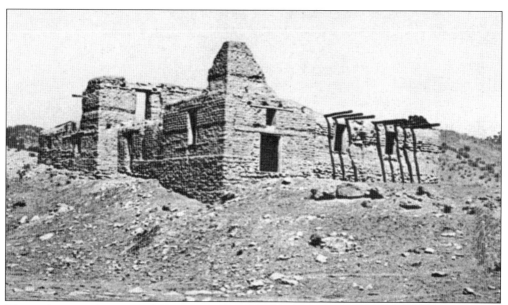

These photographs—a Fred Harvey Company postcard from 1909 (above) and an image by archaeologist Nels Nelson (see chapter four) in 1912 (below)—show the ruins of a large adobe walled structure. The caption on the back of the postcard reads, "The town of Lamy [a railroad stop about 18 miles south of Santa Fe] . . . was named for the good Archbishop [Jean Baptiste Lamy, 1814–1888] who founded nearby a convent, the walls of which are still standing, and who also once taught the Indians in a little adobe school house." When the convent was founded, he was a missionary priest. Unfortunately, no other information could be found about this structure. However, Bishop Lamy did take a land claim near the town in trust for the Catholic church in 1857. (Above, ACS; below, AMNH No. 242.)

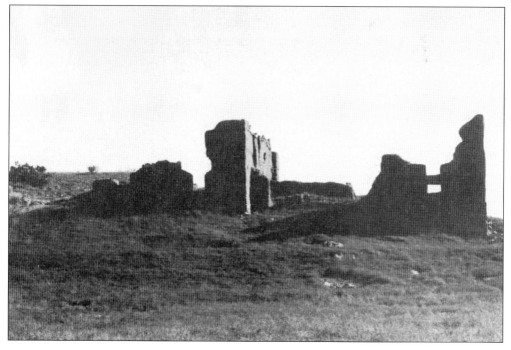

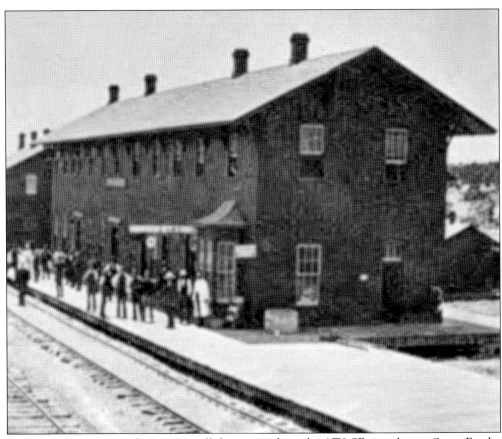

Lamy was, and remains, the jumping off place to get from the AT&SF main line to Santa Fe, the grade into Santa Fe being too steep for trains. The photograph above shows the first Lamy depot around 1880. Below is the new 1909 depot in the Mission Revival style, the preferred architectural style of the AT&SF. (Both, CSWR.)

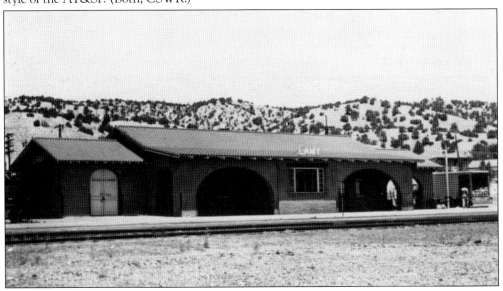

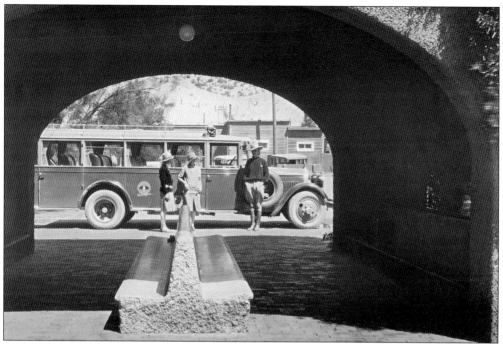

Much has been written about the Fred Harvey Company, the famous Harvey Houses, and their 1920–1930s Indian Detour Tours of the Southwest (see Arcadia's 2008 *Harvey Houses of the Southwest*, 2014 *Pecos*, and 2016 *Bandelier National Monument*). Both of these photographs are from the late 1920s; above is a "Harveycar" picking up "dudes," as the tourists were called, at the Lamy train station, and below is another Harvey publicity photograph showing the inner courtyard of the Harvey House, El Ortiz Hotel, in Lamy. (Both, DD.)

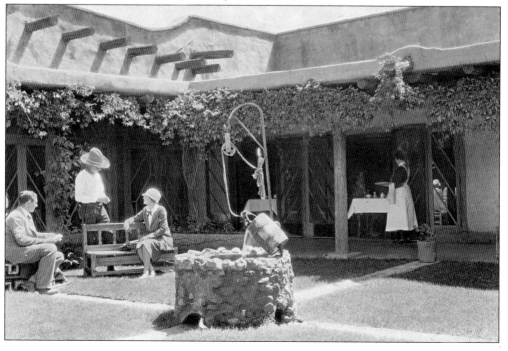

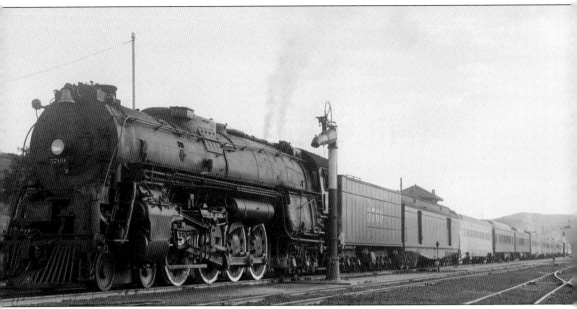

This photograph, as with the first image of this chapter on page 46, was taken at Lamy. It shows the AT&SF California Limited in 1938 on its run from Chicago to Los Angeles. The locomotive is a coal fired Baldwin 4-8-4 Northern Class, built in 1938 with 80-inch drive wheels. Several of these locomotives survive, including No. 2926, which at the time of publication is undergoing restoration in Albuquerque. (ACS.)

Three

THE ORTIZ AND SAN PEDRO MINES

The Ortiz and San Pedro Mountains form the western border of the Galisteo Basin and contain highly mineralized beds of garnetized limestone. When magma of sufficient heat and pressure pushes through limestone it can produce garnet mineralization associated with ore bodies. Gold and silver, as well as many base metals such as copper, lead, and zinc, can be found in such zones.

Native Americans in New Mexico did not care about gold or silver, but were looking for lead minerals for glaze pottery paint, as well as blue and green stones used for decoration and precious objects. The Spanish were more interested in silver than they were in gold. It was not until the early 19th century that gold became a focus of attention, initially for Hispanics with the discovery of gold dust and nuggets in placer deposits. Later in the 19th century, copper was the metal of choice for Anglos, as the developing electrical industry demanded lots of copper wire.

Mining in the Ortiz Mountains to the north was mostly about silver and gold, while in the southerly San Pedros, the focus was primarily on copper.

In 1580, Francisco Sanchez Chamuscado, in addition to finds in the Cerrillos Hills, discovered mineral deposits in the San Pedro Mountains that he called Las Minas de Santa Catalina. Remnants of smelting from the 1650s have been excavated by archaeologists near Golden.

The earliest identified gold, from the 1820s, comes from placer deposits in which the gold eroded out of its source rock in the mountains and was distributed by flooding in sands and gravels. By the 1830s, underground "lode" mines were finding gold in this source rock.

Blue/green copper minerals had attracted attention to the region since prehistoric times. But metallic copper extraction required large-scale capital and did not end up dominating mining in the San Pedro Mountains until well into the 20th century.

Considerable information on the Ortiz Mountains is found in William Baxter's 2014 book *Gold and the Ortiz Grant: A New Mexico History and Reference Guide*, and for the San Pedro Mountains from recent state and federal archaeological surveys, particularly the informative 2017 pamphlet *Spanish Silver, Mexican Gold and American Copper* by Avi Buckles of Westland Resources Inc.. A number of the images contained in this chapter come from the Henderson family and are published here for the first time. The Henderson Store in Golden, New Mexico, has been in continuous operation since 1918.

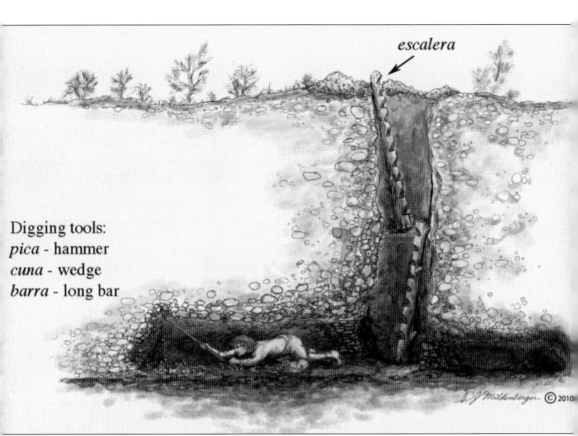

escalera

Digging tools:
pica - hammer
cuna - wedge
barra - long bar

There was no significant gold mining in New Mexico before 1821. However, with the creation of the Republic of Mexico and the Santa Fe Trail bringing more people to New Mexico, along with the discovery of meaningful gold deposits, things changed fast. Often, this gold was concentrated on a base rock level 20 to 80 feet below the surface. To get to it, a technique of placer mining, called "deep-placering" was developed in the Ortiz Mountains at a place called Placer Viejo or the "Old Placers" sometime after 1821 (see map on page 2). This illustration shows how it worked. (Joe Mildenberger.)

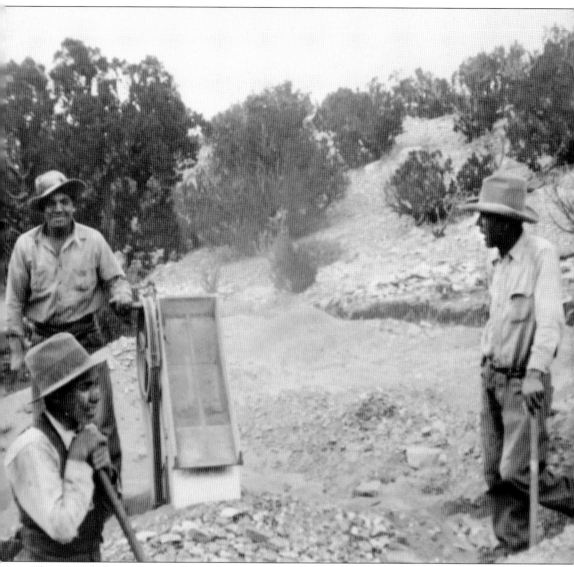

The miners below are using a dry washer to extract gold from deep placer deposits a few miles south of the Old Placers in an area between the Ortiz and San Pedro Mountains called the New Placers, or Placer Nuevo. This area came into prominence in 1839 and quickly surpassed the Old Placers. During the Mexican period between 1821 and 1846, as much as 50,000 ounces of gold, which is equivalent to a solid cube of gold 45 inches on each side, came from the Ortiz Mountains, most of it from the New Placers. A dry washer uses air rather than water to separate heavier pieces of sand, hopefully including gold, from lighter sands. It was introduced from California in the 1870s and became very popular. This type of mining was mostly done in the winter, when there were no crops to tend and when melted snow could be used to wash out the gold from heavy sands in a wooden bowl called a *bateas*. (HR.)

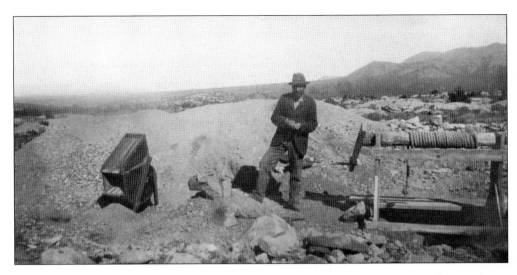

When Charles Lummis, famous for his work in preserving missions and founding the Southwest Museum in southern California, visited the New Placers in 1884, he described them as "Walking through . . . countless well-like holes, 30 to 40 feet deep and about 4 feet square. Over each is a rude but effective windlass. . . . An inch rope of sufficient length lets down the miner into an untimbered shaft. At the bottom he begins to 'drift out' horizontally until he strikes a 'pay-streak.'" While dry washing was the common technique to separate out waste sand and gravel from gold, ironically, most paying gravels were too moist to use dry washing alone. (Both, HR.)

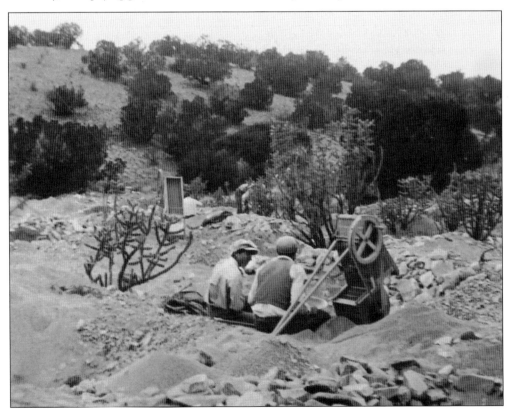

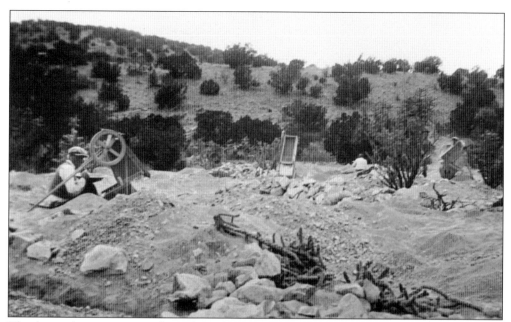

The dry-washing operations shown here date from about 1900. Earth is shoveled into the upper part of the machine, and the hand-cranked agitator and gravity do the rest. The heaviest bits of remaining soil are collected and later washed to separate out the gold. The claim ownership of these placer operations was often contentious and difficult to enforce, especially as specific sites were not operated year-round. (Both, HR.)

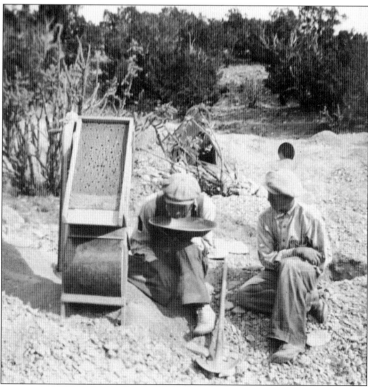

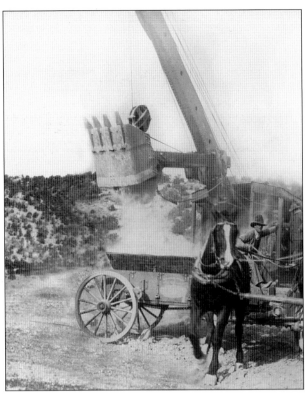

No one is going to get rich digging by hand. To obtain meaningful gold requires moving a lot of soil. In California, hydraulic mining, a process of washing gravel away with a high-pressure hose, was extensively used. Vast areas in the High Sierras were subject to this environmentally destructive process. But it requires a lot of water. So, in the Ortiz and San Pedro Mountain placers, the next step up from hand digging was using a steam shovel. Here are photographs of such a shovel at work in the New Placers east of Golden. A bucket load of soil is dropped into a heavy-duty freight wagon and taken to a large-scale separator (see page 81). (Both, HR.)

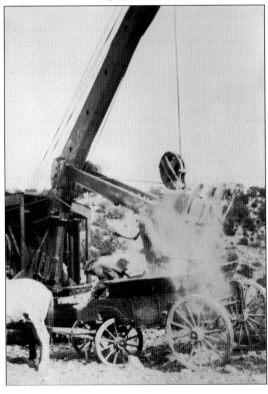

The steam shovel operation seen at right was active sometime around the turn of the 20th century. It looks to be moving as much soil as possible, with one wagon after the next moving as quickly as possible. Action shots from this period are quite rare and this series shows the wagon/shovel operation in its entirety. The woman in the photograph below seems to be taking the steam shovel for a spin. (Both, HR.)

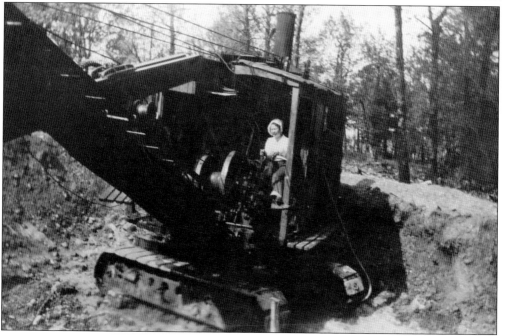

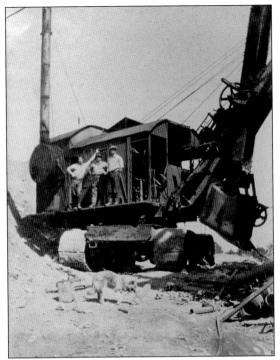

Prior to 1905, the Monte Cristo Co. had unsuccessfully operated a "dipper dredge," a steam shovel on a barge. The company built a pond and filled it with well water. This did not work very well, as the water just drained through cracks in the bedrock. But to move massive amounts of gravel requires massive equipment. The steam shovel pictured here is of the type used during construction of the Panama Canal, several of which are known to have found their way into western mining districts. An even bigger machine, called a traction dredge, was also employed, as seen below. A traction dredge (called such because it moved under its own power) that cost $50,000 was operated in the New Placers by the Gold Bullion Mining Company in early 1906. However, it was reported in 1908 that due to delays in supplies and machinery, the dredge did little work. (Both, HR.)

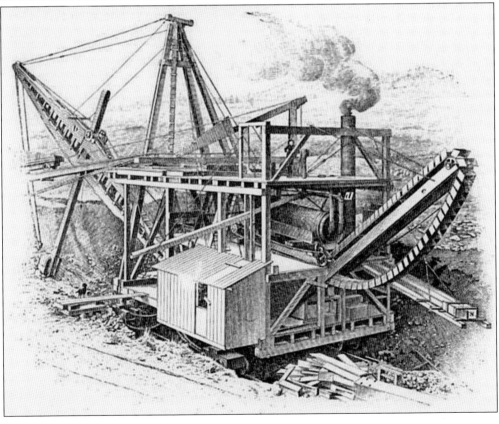

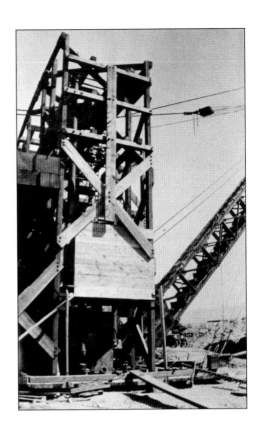

The Racine Mining Company also experimented with a machine called a dry-land dredge in the early 1900s. Perhaps these photographs are of that contraption. Even using a dry-land dredge requires some water. Several wells initially yielded as much as 25 gallons per minute, but it is doubtful that this would have continued indefinitely, much less provide enough water to wash gold out of sand and gravel. The dredge machine could handle 75 cubic yards of soil per hour, and gold was said to have been separated out using mercury, although fortunately, no traces of residual mercury have been found in the area. (Both, HR.)

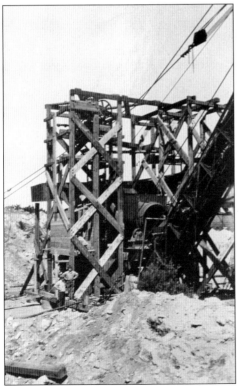

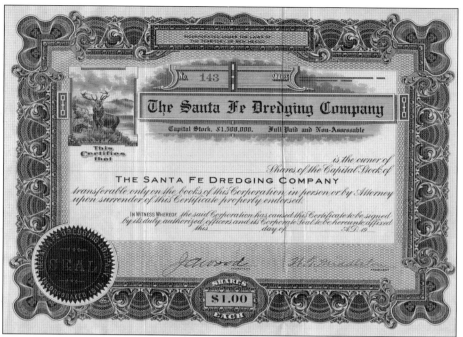

Probably the best way to make money from mining is to open a saloon, or sell picks and shovels, or better yet, sell stock. Above is a 1911 stock certificate from the Santa Fe Dredging Company. About all that could be discovered of this company is that it was selling stock in New York City in 1915 and in 1917 had ordered equipment from the Yuba Manufacturing Company of San Francisco, a major supplier of gold mining machinery. Below is a New Mexico Mining Company (NMMC) stock certificate. Incorporated in 1858, this was the first mining company incorporated in the Territory of New Mexico. (Both, ACS.)

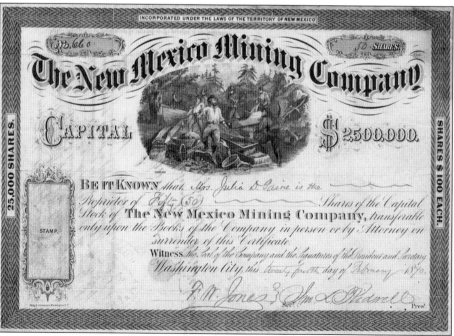

Michael (Miguel) A. Otero (1829–1882), at right, was a founding member of the NMMC. His son, Miguel A. "Gillie" Otero Jr., served as the first Hispanic governor of the New Mexico Territory from 1897 to 1906. With the railroad opening up New Mexico to the east, promotional schemes replaced mineral production as the driving force of the regional economy. One scheme attracted former president Ulysses S. Grant in 1880, who briefly accepted the offer of president of the San Pedro & Cañon del Agua Mining Company, until it became known the enterprise was mostly a stock promotion. Abraham Rencher (1798–1883), below, served three terms in the US Congress, initially as a Whig and then as a Democrat. Rencher rejected President Buchanan's offers for several appointed government offices in favor of the office of territorial governor of New Mexico. He had invested most of his money in New Mexico Mining Company stock and wanted to oversee the development of the mines. Shortly after he arrived in Santa Fe, he was elected president of the NMMC. The company failed following the Civil War, but did build the first railroad—a horse tram—in New Mexico. (Both, ACS.)

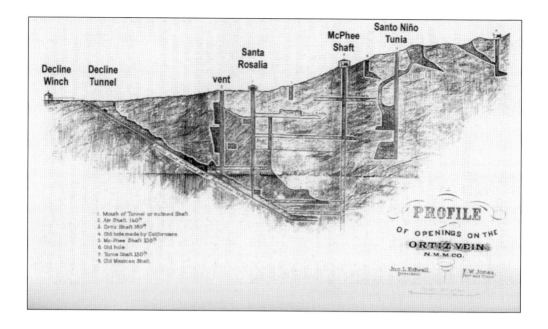

Profile of openings on the Ortiz Vein, N.M.M.CO.

1. Mouth of Tunnel or Inclined Shaft.
2. Air Shaft. 140 ft.
3. Ortiz Shaft 160 ft.
4. Old hole made by Californians
5. Mc-Phee Shaft 150 ft.
6. Old hole.
7. Tunia Shaft 150 ft.
8. Old Mexican Shaft.

Jno L Kidwell, President F W Jones, Supt and Tresr

The next step in extracting gold requires lode mining—going underground to dig it out. The drawing above is a cutaway view of the NMMC's Ortiz Mine. In 1888, the Santa Fe Gold & Copper Company (SFG&C) reopened the mine and built a new smelter and coke ovens at San Pedro. The San Pedro Mine closed when copper prices collapsed at the start of the Great Depression. In 1937, the mine was purchased by John Jacob Raskob, who is best known for building the Empire State Building in New York City. In 1944, Raskob sold the mine to Charles Bradbury, who operated it on a small scale for a number of years until selling it in 1968 to Consolidated Goldfields. The photograph below is of a pair of air compressors, probably steam driven, used in the operation of the Ortiz Mine. (Both, HR.)

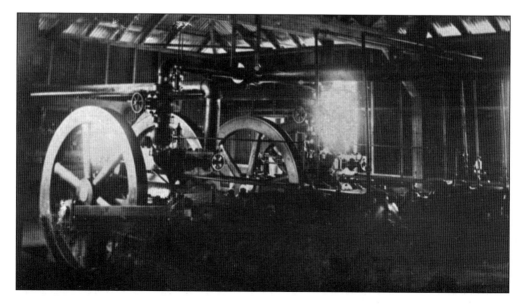

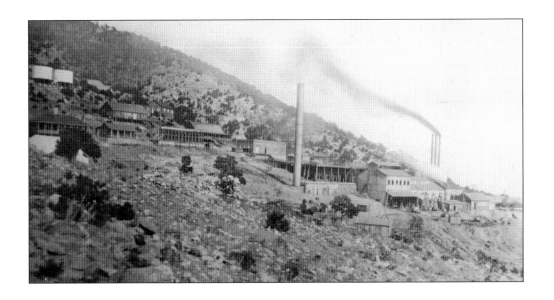

The largest of the lode mines in the San Pedro Mountains was the San Pedro Mine. From 1904 to 1967, the San Pedro Mine yielded 16,549 ounces of gold, 304,625 ounces of silver, and 7,476 tons of copper. There are several miles of tunnels in the San Pedro Mountains. The San Pedro Mine has at times had a violent history. Antonio Jose Otero, who in 1846 purchased the original Mexican grant for the Nuestra Senora de Dolores Mine, sued the San Pedro & Cañon del Agua Mining Company for encroaching on his property. The suit dragged on, and in 1883, a frustrated Otero seized the San Pedro Mine with armed men and drove the company out. While Otero eventually won the suit in 1892, he never was able to operate the mine, and control passed to the SFG&C, owned principally by Adolph and Leonard Lewisohn. (Both, HR.)

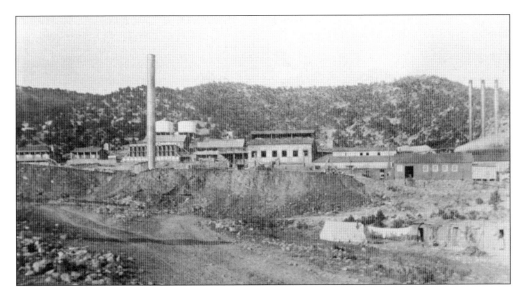

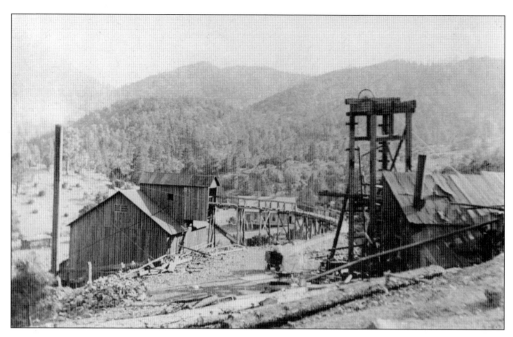

While significant New Mexican gold mining activity in the first third of the 20th century was primarily lode mining in the San Pedro Mountains, much of the real "pay dirt" was for copper. There was a considerable demand for copper wire in the late 19th century as the use of electricity, especially for power and telegraph lines, as well as for motor and generator windings, became prominent. Shown here is the McPhee shaft, one component of the Ortiz Mine. The shed to the upper right is the head-frame over the shaft into the underground workings. The structure at left is the steam engine powerhouse; note the tall smoke stack for the boiler. Ore was preprocessed using a stone-filled rock-crushing wheel. (Both, HR.)

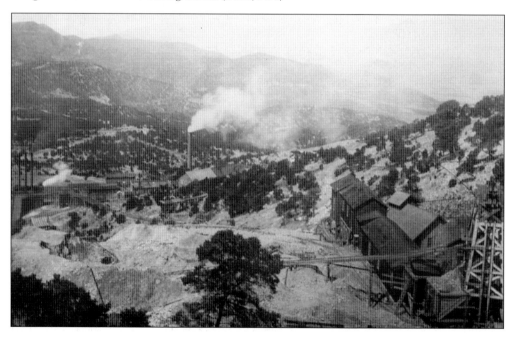

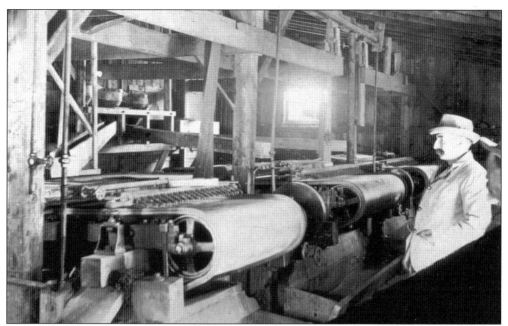

This machine is part of the ore separator mechanism inside the mill of the San Pedro Mine. Powdered ore in a slurry was poured onto fabric rollers and the water drawn out as part of the process to concentrate the ore prior to smelting, which extracts the metal. The last mining there was the reworking of waste rock from the mine to extract garnet for industrial use in the 1980s. The mine was for many years a prime location for mineral hunters; however, the mine is on private land and there is no public access, and all of the entrances have been closed for public safety. This included backfilling 23 shafts and adits, along with the installation of bat grates to allow bats access to some tunnels. The photograph below is of R.J. Iverson checking ore for gold. Note the hand pulverizer/mullet behind him used for crushing ore samples for testing. The tall plants in the background are called "miner's candle" (*Cryptantha virgata*) because their oily stems burn well. (Both, HR.)

These photographs were found in the personal effects of Richard Justus "R.J." Iverson (1880–1955), superintendent of the Las Vegas Mine in the San Pedro Mining District from 1932 until it closed in 1942. Iverson married Dr. Madolin Breckenridge (née McDowell) (1879–c. 1942) in 1936. She was born in Ohio and, after being widowed in 1916, was a practicing osteopathic physician in Denver in the early 1920s. By the 1930s, she had an office in Albuquerque and at some time during this period met Iverson. Together, they lived at the Argo Mining Company's Las Vegas Mine near Golden, although she continued to maintain her office in Albuquerque. At left is a picture of her as a young woman, probably in Ohio, and below is a later image, most likely from when she lived in Denver. (Both, HR.)

Perhaps Dr. Madolin Breckenridge spent more of her time during the winter in Albuquerque; the winters in the San Pedros can be very cold and snowy. However, at right is a photograph of her during the summer at an unknown location, likely in the mountains of New Mexico. The photograph below shows Madolin and Richard J. Iverson on a shopping trip in downtown Albuquerque sometime in the early 1940s. Iverson spent his later years in rented rooms in Golden. (Both, HR.)

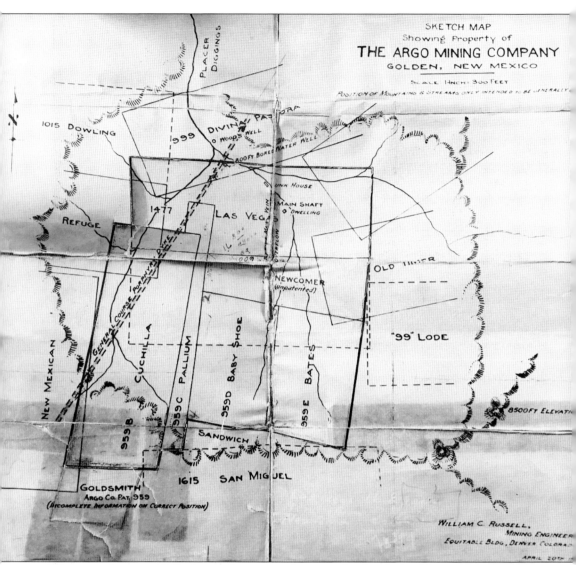

This map, drawn in 1920, shows the mining claims in the San Pedro Mountains of the Argo Mining Company of Milwaukee, Wisconsin. The Las Vegas Mine is at center, and the residence and bunkhouse buildings (shown on page 93) are also noted. The Argo claims in New Mexico date to 1896, with incorporation papers filed in Cerrillos listing $50,000 in capital stock. (HR.)

The copper boom of the late 19th century attracted large amounts of eastern American capital that funded industrial-scale mining activities. The key operations, in addition to the Argo Mining Co., included the San Pedro & Canon del Agua Co. (1880), Santa Fe Copper Co. (1888), and the Santa Fe Gold & Copper Mining Co. (1899). The small communities of Golden and San Pedro (see Arcadia's 2013 *The Turquoise Trail*) rapidly grew with this influx of activity. The photographs on this page, along with those on the next three pages, are all of the Argo Company's Las Vegas Mine and were found in Richard J. Iverson's personal effects following his death. These photographs appear to date from the early 1930s. (Both, HR.)

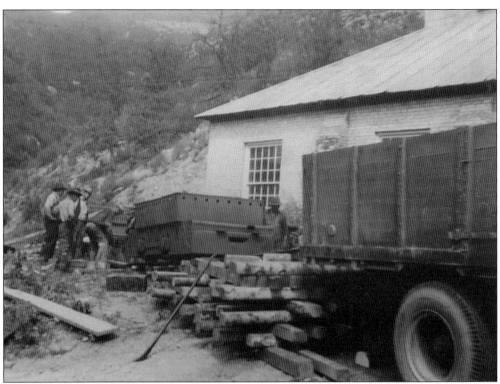

Copper mining consisted of much more than underground mines and the communities that supported the miners. There were also power houses with steam engines powering generators, compressors, blowers, hoists, and pumps, along with water wells and pumping, electrical transmission systems, mills, smelters, coking ovens to turn coal into coke (which is almost pure carbon like charcoal, burning hotter and with little smoke), as well as an aerial tramway to transport ore. Little remains today of all this activity. The photograph above shows a truck off-loading equipment at the San Pedro Mine, and below is a hit-and-miss gas engine and water tank; the water was needed to cool the engine. (Both, HR.)

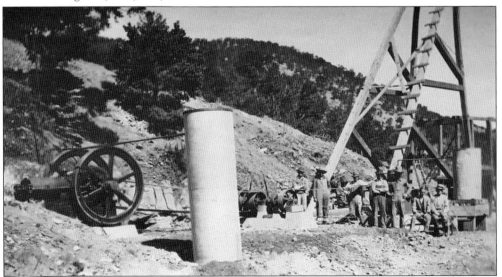

Getting up into the mountains, especially in the winter, was no easy task. But the mines required good access, and well-made roads were established throughout the mining zone. Both of these vehicles were photographed at the Argo Mine in the early 1930s. (Both, HR.)

Both of these photographs are of Supt. Richard J. Iverson at the Argo Mine; at left, he is standing beside a tank for pressurized air used to operate equipment, such as pneumatic drills, in the mine, while the photograph below shows him with the mine's gravity-fed mill, where ore was crushed and processed prior to smelting, in the background. (Both, HR.)

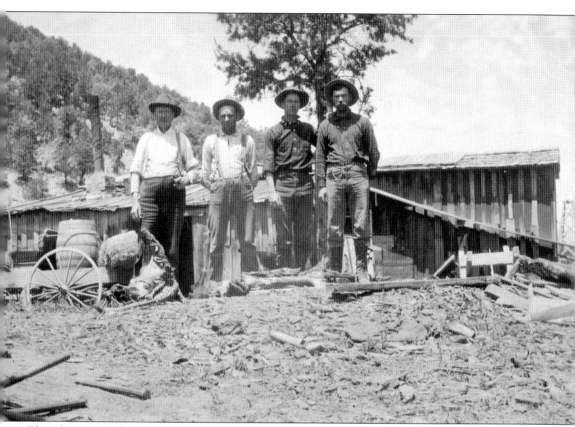

This photograph from the New Mexico Bureau of Geology & Mineral Resources archives shows four miners sometime in the first quarter of the 20th century at one of the shafts of the Las Vegas or San Pedro Mine high in the San Pedro Mountains. The extensive tunneling in these mountains resulted in a number of mines becoming interconnected. One could enter on one side of the mountain and come out on the other. (BMG sh-00799.)

The words "stock promotion" are commonly understood to be preceded by the adjective "fraudulent." The NMMC's principal owner, Stephen B. Elkins (1841–1911), at left, promoted a plan to use a secret waterless electrostatic method gold extraction mill invented by Thomas Edison. On August 16, 1900, eighteen pounds of ore concentrated by this machine were assayed but proved to be of poor quality and below a value required to keep the operation running. The electrostatic component of the mill was never installed, and the operation was completely closed down in early November 1900. Edison lost his entire investment, said to have been considerable, and the mill building was torn down in 1907 for scrap lumber. Today, the site of Dolores and the Edison mill are devoid of any indication of past human activity and the property is off limits to the public. About all that remains of its legacy is a cowboy song and mentions in a few texts on mining history. (Left, SAC; below; MAC.)

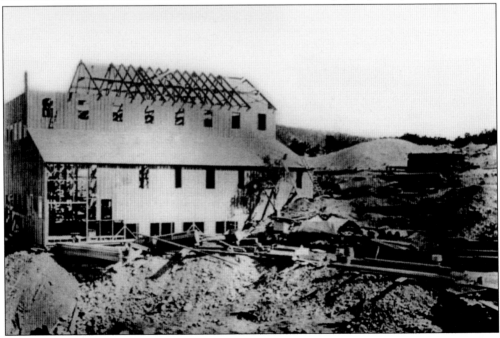

This advertisement for the principal mode of transportation to the San Pedro area appeared in a July 16, 1889, issue of the San Pedro newspaper called the GOL-9-DEN. This stage probably connected to the AT&SF main line at either Lamy or Kennedy and made its way south to the San Pedro Mountains. The image below is from a 1924 railroad map of New Mexico prepared by the state corporation commission. It shows the route of the New Mexico Central Railroad south from Santa Fe, as well as the AT&SF lines. The New Mexico Central was a 115-mile standard-gauge railroad between Santa Fe and Torrance County. Originally constructed by the Santa Fe Central, the line was opened for operation in 1903. (Both, SAC.)

GREENWOOD'S STAGE !

Connects with A. T. & S. F. Trains and will carry passengers and Express to

Dolores, Golden, and San Pedro.

Leave express orders at Wells, Fargo's office or at stage office, Cerrillos.

E GREENWOOD, Prop'r

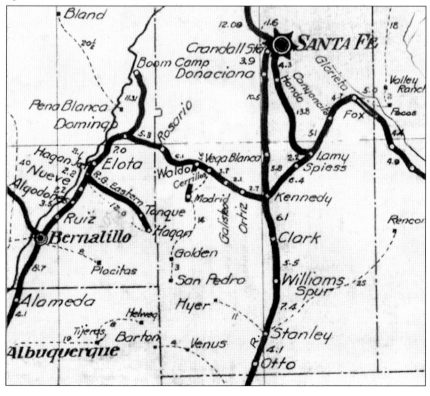

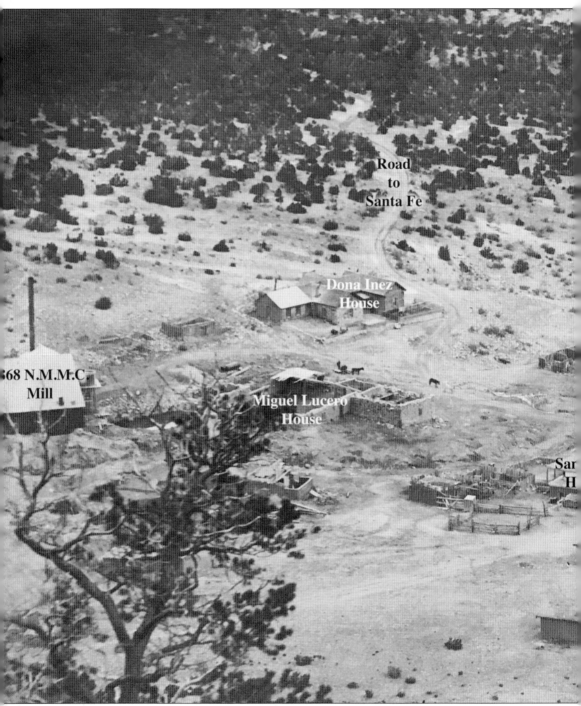

Road
to
Santa Fe

Dona Inez
House

368 N.M.M.C.
Mill

Miguel Lucero
House

Sar
H

The name Dolores commemorates Mater Dolorosa, Mother of Sorrows, one of the titles for the Virgin Mary and a fairly common place name in the Southwest. William Gillet (1830–1904), in his 1885 book *Illustrated New Mexico*, describes a local tradition telling of some freighters who lost their oxen in a canyon in the Oso, later called Ortiz, Mountains. The oxen were found, but one died soon after. The freighters cut open the ox to see if they could determine its cause of death,

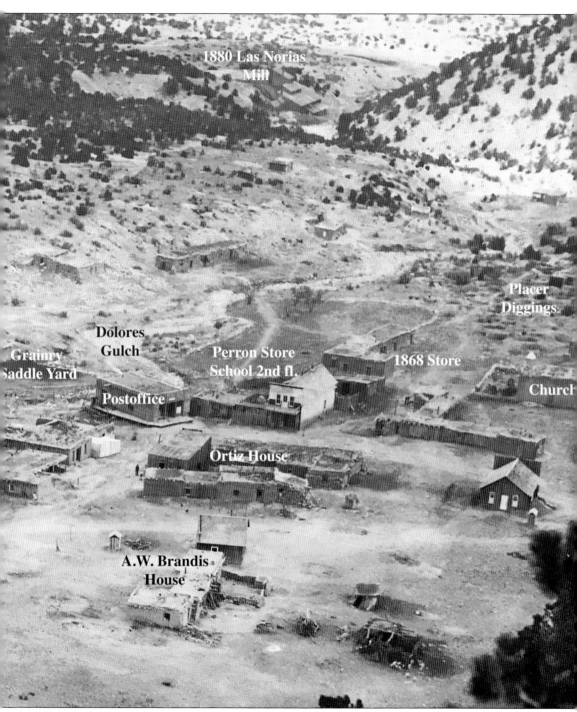

1880 Las Norias Mill

Placer Diggings

Dolores Gulch

Grainry

Saddle Yard

Perron Store
School 2nd fl.

1868 Store

Church

Postoffice

Ortiz House

A.W. Brandis House

and inside the stomach they found a large nugget of gold. They reasoned that the animal had swallowed the gold while drinking from a nearby spring. After a considerable search, they found the place, along with more gold. This set off a gold rush at Old Placers in 1821. The town of Real de Dolores del Oro was established near this spring by the prospectors working the district. This photograph shows Dolores from Cunningham Hill around its peak in 1894.

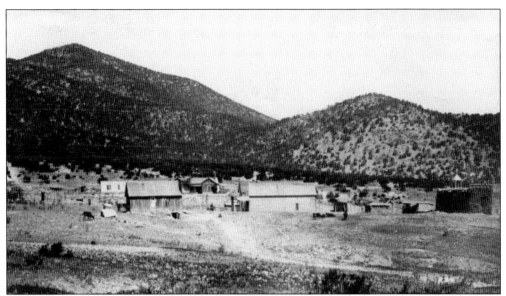

In 1893, the citizens of Dolores filed suit in the US Court of Private Land Claims to confirm that the town centered around the church was formed under Mexican law in 1830. In 1897, Gov. Miguel Otero denied the claim, and his judgment was upheld by the Supreme Court in 1899. The town and lands around it then fell under the ownership of the New Mexico Mining Company's Ortiz Grant, which was managed by Samuel H. Elkins, younger brother of Stephen B. Elkins. Thus began the final demise of Dolores. The census of 1900, the last enumeration for Dolores, listed 136 people in 28 houses, over half of whom had Hispanic surnames, about the same population as 20 years earlier. Interestingly, at that time, only 40 percent of the working population of Dolores depended on mining for a living. (Both, TPB.)

These two photographs show the main street in Dolores sometime in the early 20th century after it had become mostly abandoned. The two-story building with the balcony was the Perron Store. The town's public school had been on the second floor. The school term was three months, and the pay for teacher Belle Sweet (1879–1968) was $20. She was the first and, by 1905, the last school teacher in Dolores.

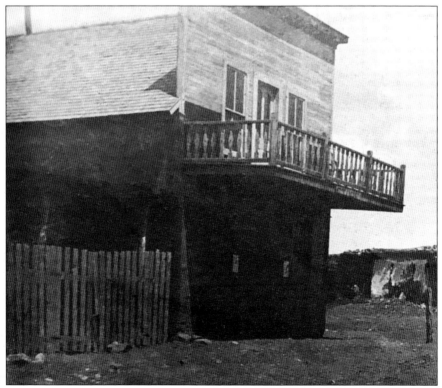

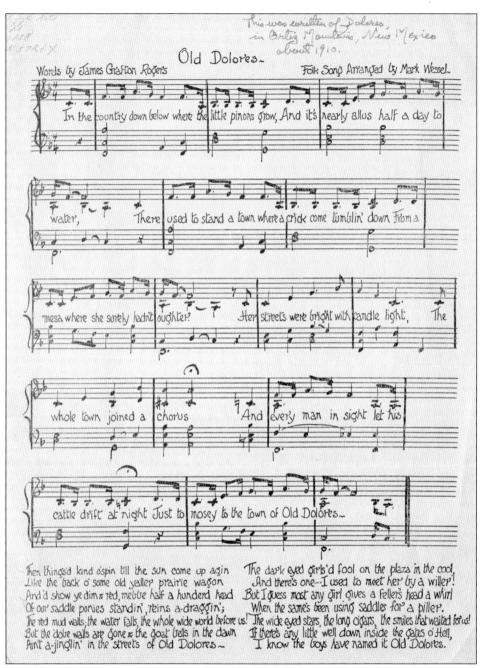

This wonderful cowboy song is about the town of Real de Dolores del Oro. The sheet music shown here was discovered in the archives of the University of New Mexico's Fine Arts Library. James Grafton Rodgers (1881–1971), who wrote "Old Dolores," was born in Denver, where he spent most of his life except for a stint as assistant secretary of state in the Hoover administration. He achieved preeminence as a lawyer, public servant, civic leader, international financier, diplomat, expert in military intelligence, historian, teacher, educational administrator, author, researcher, playwright, and songwriter. He was also dean of law schools at both the University of Colorado and Denver University, as well as president of the Colorado State Historical Society. (FAL.)

Four

THE ARCHAEOLOGISTS

Within the Galisteo region are a number of large pueblos that were occupied between 1275 and 1550, including Shé, Colorado, Blanco, Arroyo Hondo, San Marcos, Largo, San Cristóbal, Las Madres, San Lazaro, Galisteo, and Piedra. None of these sites have been fully excavated, but estimates for each range from 500 to 4,000 rooms. There are also several pueblos that were totally destroyed before archaeologists were able to record them, including La Cienega, Puedo, and Puerto/Tuerto. One of the largest and most significant pueblos in the area is San Marcos. Unfortunately, no historical photographs of this site were available and it is not included in this chapter.

In 1909, Archer M. Huntington (1870–1955), a trustee of the American Museum of Natural History (AMNH), funded 10 years of research in the Southwest. Nels Christian Nelson (1875–1964), a 1908 graduate of the University of California, Berkeley, was hired by the AMNH as an assistant curator of anthropology and tasked with carrying out the Huntington-funded research. Clark Wissler, curator of the Department of Anthropology, who had hired Nelson, described the objective of Nelson's work in the Southwest as "a systematic investigation of the prehistoric pueblo cultures in the Rio Grande . . . [and] to excavate some of the sites abandoned about the time of the Spanish occupation . . . correlating the results [with ethnographic] work on living peoples." This chapter includes photographs from Nelson's 1912 excavations, with many published here for the first time.

Bertha Pauline Dutton (1903–1994) was a seminal figure in Southwestern archaeology. While still working on her PhD dissertation in archaeology, she designed and coordinated a program between the Girl Scouts of America and the Museum of New Mexico that ran from 1946 through 1957. What began as a "mobile" summer camp to introduce young women to Southwestern archaeology had turned into a full-scale field school at Pueblo Largo by 1951. Aside from Nels Nelson's excavations, the site was essentially undisturbed. Dutton taught the "Dirty Diggers," as the Girl Scouts called themselves, that they were participating in a serious scientific inquiry, not a treasure hunt.

In recognizing the unique qualities and tremendous significance of the sites in the area, Congress passed the Galisteo Basin Archaeological Sites Protection Act in 2004, which calls for the identification and protection of archaeological sites in the greater Galisteo region.

For a recent discussion of the Galisteo Basin, see Lucy R. Lippard's excellent book *Down Country: The Tano of the Galisteo Basin, 1250–1782.*

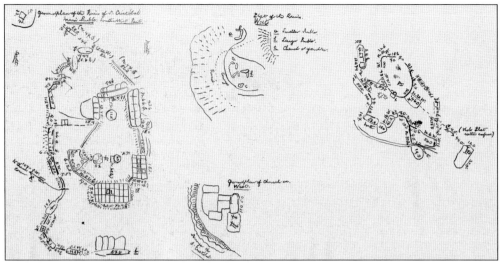

On July 7, 1882, Adolph F. Bandelier was the first anthropologist to visit San Cristóbal Pueblo. Above is the sketch map he made of the site. This is one of the largest pueblos in the Galisteo Basin, containing an estimated 1,645 ground floor rooms in 17 room blocks, the remains of an early 17th century Spanish Colonial mission church and *convento*, a masonry shrine, an incredible array of petroglyphs and pictographs, a massive sandstone slab wall, and a large earth and stone reservoir. Other features include a series of *tipi* rings located outside the stone wall, indicating trade with Plains tribes, as well as agricultural fields. Occupation dates range from 1250 to 1600. Nels C. Nelson excavated at Galisteo Pueblo from July 24 to September 23, 1912, the first time he dug in the Galisteo Basin. Nelson and his wife, Ethelyn, spent their honeymoon here living in a rock shelter. Below is his map of the site showing the 239 rooms he excavated. The Tewa name for the village is Pant-ham-ba or Yamp'hamba, meaning "narrow belt of willows." It began as a small community on the northern side of the arroyo with the centers shifting back and forth as it grew on both sides. It was vacated about 1680, when the remaining inhabitants moved to Santa Fe following expulsion of the Spanish. (Above, CSWR; below; AMNH 1914.)

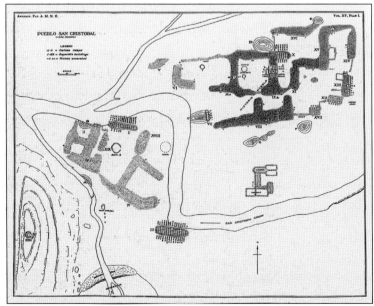

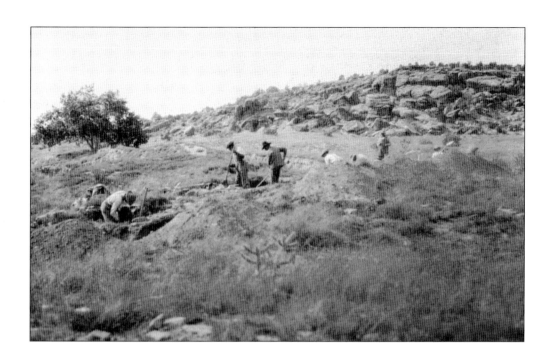

These photographs show workers during excavations of one of the room blocks. Nelson hired locals, many from nearby ranches, as diggers, a welcome addition to the local economy. In his diary, he reported that 10 men would clear an average of 10 rooms a day, each to an average depth of seven feet. This is disturbingly fast by today's standards. On August 3, 1912, he reported that, "I had looked for more specimens in the way of pottery. As a result I offered to pay the men 25-cents out of my own pocket for each whole pot found—which may or may not be a good venture." (Above, AMNH No. 143; below, AMNH No. 154.)

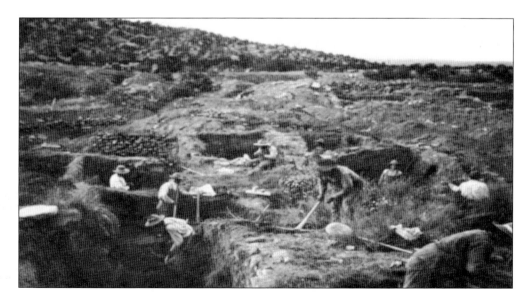

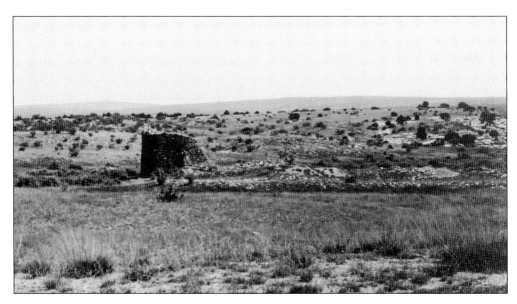

The standing wall in the photograph above is what remains of a chapel built about 1620, as seen in 1912. In 1621, Fray Pedro de Vergara was in residence, but by 1626, it was reduced in status to a *visita*, meaning that there was no longer a resident priest; instead, it was visited by a priest from Galisteo Pueblo. The photograph below shows the Nelson excavation of a *kiva* (a circular room used for ceremonies) inside a room block; it was one of four—in this case "Kiva B"—reported by Nelson. There are numerous pictographs near San Cristóbal, as well as a "world quarter shrine" (see page 116) on a small rise southwest of the pueblo. (Above, NN, No. 92; below, NN No. 149.)

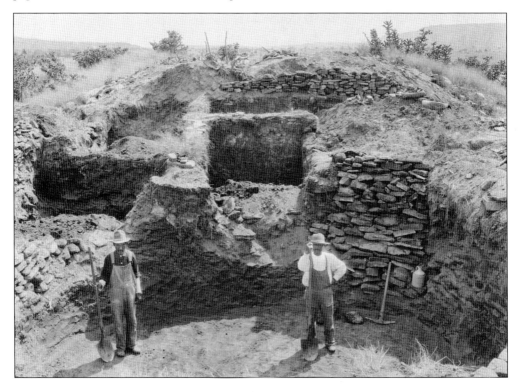

The dryness of the site and the fact that large portions of it did not burn led to the preservation of perishable material in a number of rooms. At right, the Nelson excavators have uncovered an intact roof. Pueblo peoples would have spent a considerable amount of time on the roofs of their dwellings; the dark, small rooms were used primarily for sleeping and storage. Below is a stratigraphic section through a deep midden being washed out by San Cristóbal Creek, identified as refuse heap "B" (see page 104). Nelson's 1916 publication in *American Anthropologist, Vol. 18*, "Chronology of the Tano Ruins, New Mexico," is the first presentation of the stratigraphic analysis of a Southwestern site, which was likely inspired by his work on prehistoric California shell mounds. Human remains visible in the original image have been cropped out. (Right, NN No. 166; below, NN No. AA1916.)

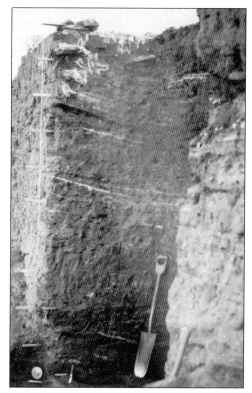

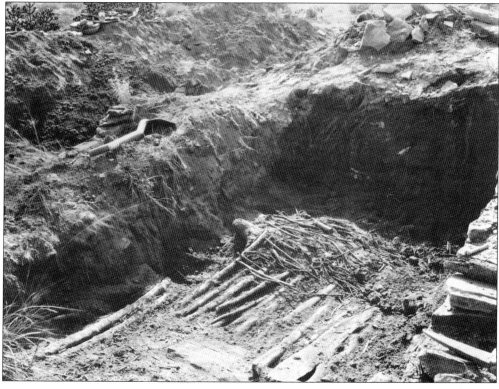

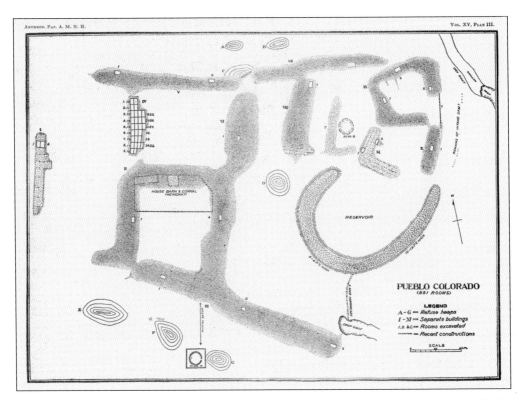

PUEBLO COLORADO
(881 ROOMS)

LEGEND
A - G = Refuse heaps
I - XI = Separate buildings
1, 2, &C. = Rooms excavated
------- = Recent constructions

SCALE

Pueblo Colorado was a large masonry pueblo containing up to 1,000 rooms in 21 room blocks and four or more kivas. Ceramics indicate the pueblo may have been first settled as early as 1200, although the major occupation and building activities took place between 1325 and 1625. Unlike other pueblos in the vicinity, Pueblo Colorado saw a decline in population and eventual abandonment during a period when other villages were increasing in size. It is possible that Apache depredations may have been responsible for the early abandonment. Seen here are Nelson's map of the site and a photograph from the adjacent mesa looking down on the Pueblo. (Above, NN No. 1914 ; below, NN No. 225.)

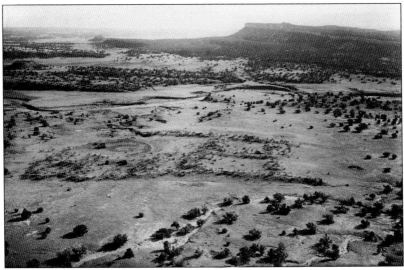

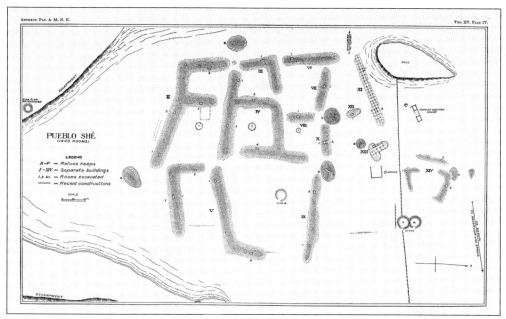

PUEBLO SHÉ
(1543 ROOMS)

LEGEND

A–F = *Refuse heaps*
I–XIV = *Separate buildings*
1,2 &c. = *Rooms excavated*
~~~~~~~~ = *Recent constructions*

SCALE

Pueblo Shé was occupied from 1325 to about 1525. A Spanish chronicle states that this pueblo and several others were destroyed by Native Americans perhaps related to Apaches. It has around 1,543 ground-floor rooms in about 16 room blocks enclosing up to 10 plazas. The site has two reservoirs, rare in prehistoric northern New Mexico. However, Pueblo Shé is one of a cluster of six sites in the Galisteo Basin with reservoirs. These features remain poorly understood, and future research can help determine the reservoirs' capacities, changing subsistence patterns, and water conservation practices. There are possible associations of reservoirs with shrines. Below is a large shrine overlooking Pueblo Shé identified as "Kiva D or Watchtower" on Nelson's map. (Above, NN No. 1914; NN No. 229.)

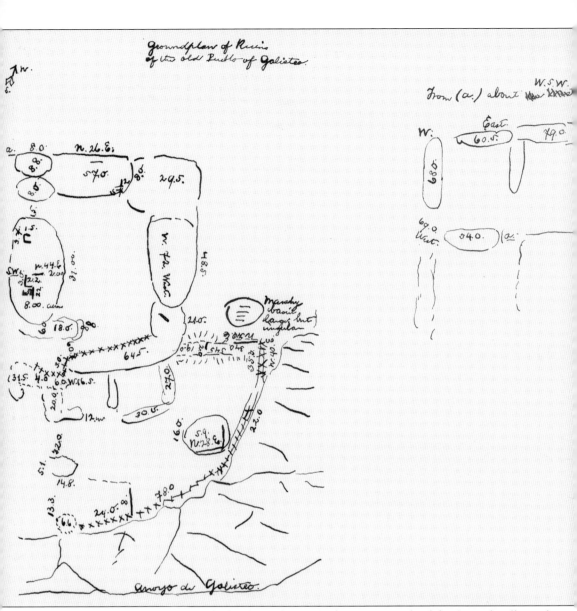

Galisteo Pueblo is located on the banks of the Rio Galisteo just north of the Spanish village of Galisteo and is more accurately called Tanu'ge, meaning the "Tano Place." It had around 1,600 ground-floor adobe rooms around 20 plazas. This is Adolph Bandelier's 1882 sketch of the site.

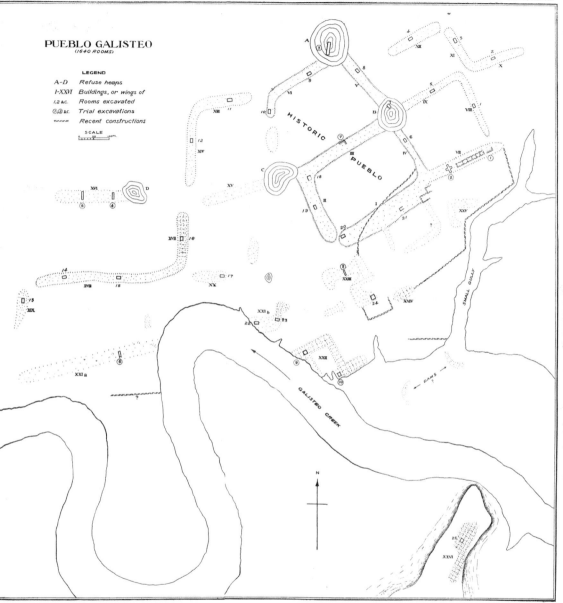

This is Nelson's 1912 drawing of the Galisteo Pueblo ruins. This site was well known in early historic times and may have been visited by Coronado in 1540 (which he called Ximena), as well as by Rodriguez in 1580, de Sosa in 1591, and Oñate in 1598, who called it Santa Ana. A church built in 1610–1611 was destroyed during the 1680 pueblo revolt. (CSWR and NN No. 1914.)

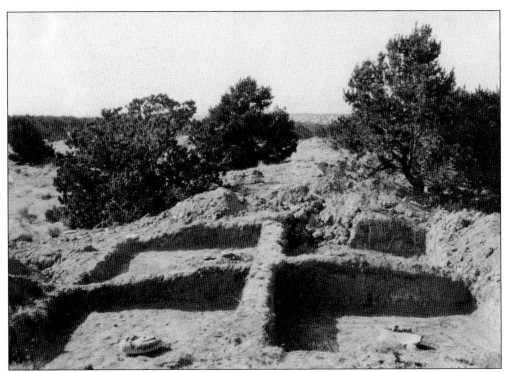

These photographs from the Nelson excavations show what happens to a pueblo made primarily of adobe—it melts. Pueblo people used a construction technique known as "puddled adobe," in which adobe mud mixed with straw and gravel/sand is coursed basket load by basket load to build up a wall. Typically, there is a stone foundation. Adobe bricks made in wooden forms is a construction technique introduced by the Spanish. The photograph below shows a historic irrigation ditch crossing through the site past a 19th-century barn. The pueblo remains are the low mounds in a band across the center of the photograph. (Above, NN No. 704; below, NN No. 689.)

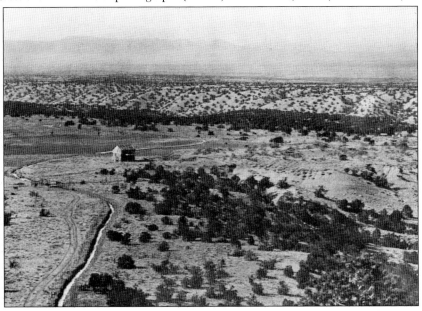

San Lazaro has a complex and debated history, right into modern times. Archaeologist Bertha Dutton briefly owned the place in the 1940s, having paid off overdue taxes, but lost it in court to the previous owner. In 1986, Santa Fe art dealer Forrest Fenn acquired the pueblo and began to dig, setting off an ongoing controversy. The site may have begun as a pit-house village in the mid-1200s. By the 14th century, it had 17 room blocks and 1,941 ground-floor rooms. Abandonment around 1500 was sudden, with much left behind, like the stone idol at right. The Spanish may have made it a *reducción* (a forced resettlement to consolidate populations) around 1613, although this has been questioned. It has also been suggested that San Lazaro was an ethnically Keres pueblo before 1500, becoming Tano or of mixed population after reoccupation. (NN1914.)

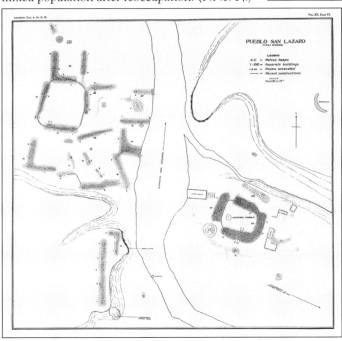

113

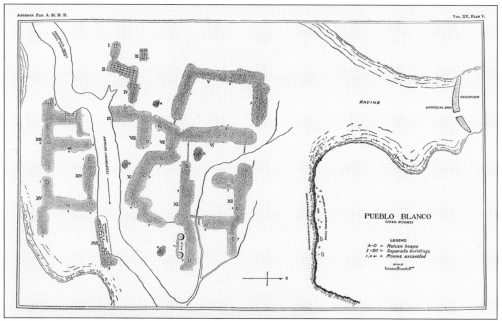

PUEBLO BLANCO
(2432 ROOMS)

LEGEND

A–D = Refuse heaps
I –XVI = Separate buildings
1, 2 &c. = Rooms excavated

SCALE

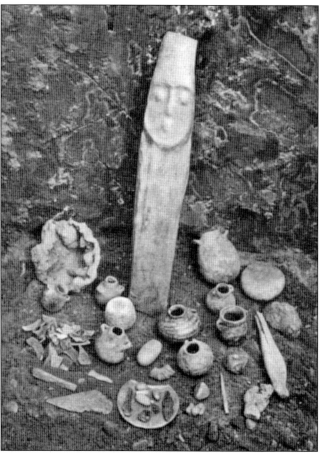

Pueblo Blanco, or Ka-ye Pu, was perhaps the last of the Galisteo pueblos to be built, although artifacts dated to 1175 have been found in the area. Nelson excavated 47 of an estimated 2,132 rooms in 16 room blocks, some of which may have been three stories in height. The rare assemblage of ritual objects at left was exposed by Nelson after being buried for nearly 400 years. The small altar was on a low platform, with a human-like image of stone surrounded by a variety of small pottery and stone objects. As the site seems to have been vacated in an orderly fashion, perhaps this altar was left as a final offering. (Above, NN No. 1914; left, NN No. 277.)

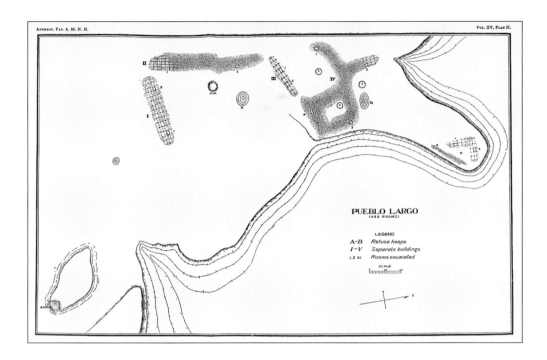

PUEBLO LARGO
(489 ROOMS)

LEGEND
A-B    Refuse heaps
I-V    Separate buildings
1,2 &c.    Rooms excavated

SCALE

This chapter concludes with a look at Pueblo Largo. In mid-October 1912, Nels Nelson excavated 13 rooms, and in the early 1950s, Bertha Dutton dug 24 more rooms. The map above is Nelson's plan of the site, and the conceptual illustration below shows what the pueblo may have looked like during its last phase of occupation in the 15th century. There are six room bocks, some two-story, containing over 700 rooms adjacent four plazas and at least six kivas. Four hundred wood samples from the site have been dated, ranging from 1270 to 1440. Although it may be one of the older of the Galisteo Basin pueblos, it is also the smallest. Pueblo Largo had two occupation phases: the first lasted about 80 years, and the second 50 years. (Above, AMNH; below, BD.)

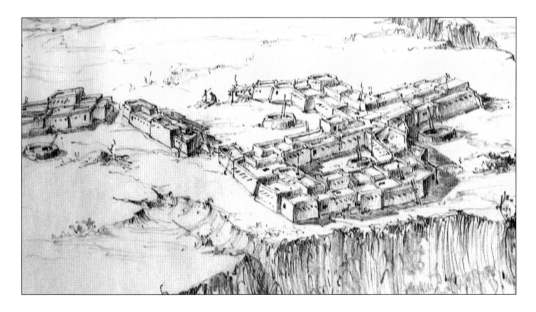

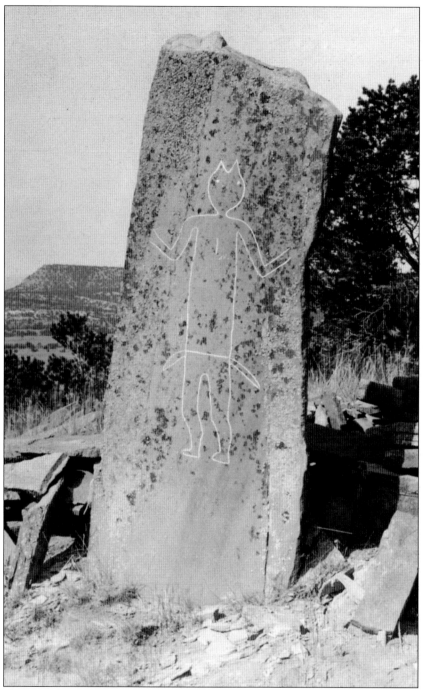

One of the most dramatic finds at Pueblo Largo was a "world quarter shrine" with this human figure carving found in a rocky outcrop southeast of room block I. Such shrines, known from the Tewa pueblos along the Rio Grande, are only seen one per pueblo and are thought to be primarily used to encourage rain, a component of nearly all rituals in the Southwest. The figure seen here was removed by Nelson and today languishes in the basement of the American Museum of Natural History. (AMNH No. 277.)

From 1951 to 1956, Bertha P. Dutton (1903–1994), in a cooperative effort between the Museum of New Mexico and the Girl Scouts of America, conducted a five-week summer field school at Pueblo Largo. This was an outgrowth of a proposal she had presented in 1947 to the American Association for the Advancement of Sciences in which it was described as a way to "widen and sharpen their perspective of the science of man. . . . An enlightened youth will be far less likely to destroy antiquities if he knows their value to society . . . the stressing of conservation in every possible way; conservation of the land itself, of the products of the land, [and] of past cultural expressions." Participating in "Dutton's Dirty Diggers," as the Girl Scouts called themselves, was to a be a life-changing experience for many of the girls. (BD.)

Information for the following captions is from *Pueblo Largo (LA183), UNM Maxwell Museum Technical Series No. 23*, 2015, by Wilson, Cohen, Gardner and Patterson. Pueblo Largo covers 120 acres on a long finger of land overlooking the Cañada Estacado. Seen here are Dutton and her girls about to leave for the site from the Laboratory of Anthropology in Santa Fe. The photograph below shows a two-story room block dated from 1268 to 1396. (Both, BD.)

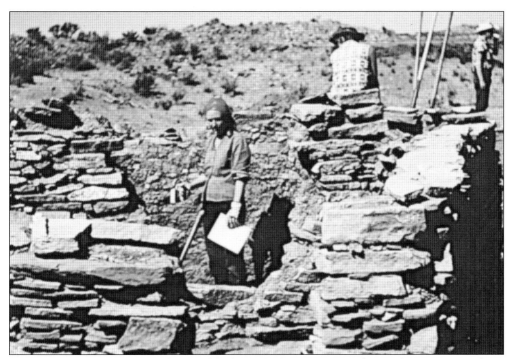

Above is a portion of the south room block V, which was excavated in 1956. It contains about 20 rooms and is perched on the edge of the mesa. Some of the rooms are oddly shaped, and one has a curved wall. A passageway at the northeast end of the room block leads to the mesa edge. Dates for this structure range from the earliest in the pueblo of about 1230 to the last occupation in the late 1400s. The photograph below shows a view from a corridor leading into a room that fronts a plaza. It is located in the northeastern corner of the room block V. A filled door opening is visible. The room contained charred corn, along with stone milling tools, bone tools, axes, hammerstones, and projectile points and was apparently occupied for several decades in the 14th century. (Both, BD.)

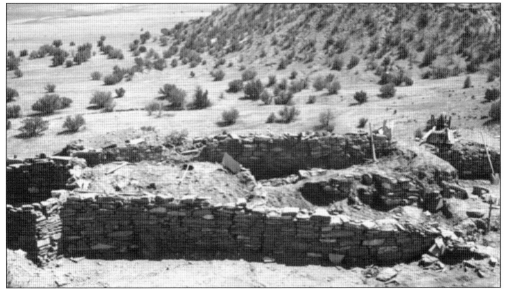

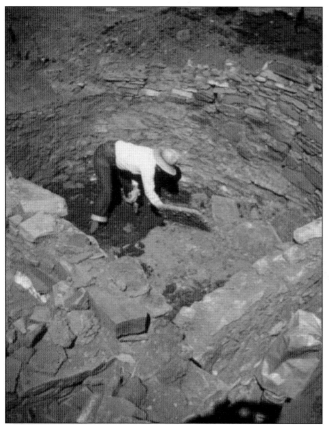

Shown at left is Kiva "A" during excavation around 1954. It is located just east of room block I. Ceramics and tree-ring dates place this structure in the first half of the 15th century. Dutton excavated here for four years, beginning in 1951, with the work supervised by Agnes Simms, a Santa Fe artist. It has the full range of features typical of northern Rio Grande communal structures. The photograph below is of a room Dutton identified as a "corner kiva." Here, Dutton exposes flagstone flooring along the inside of a curved wall that fronts a plaza. However, it may not be a kiva, given the lack of typical kiva floor features. It is reported to have been associated with turkey pens. Dating suggests that the room was repaired several times in the 14th century. (Both, BD.)

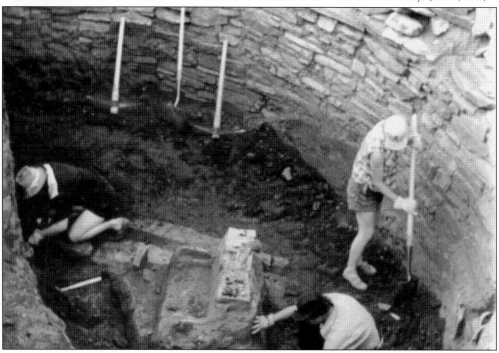

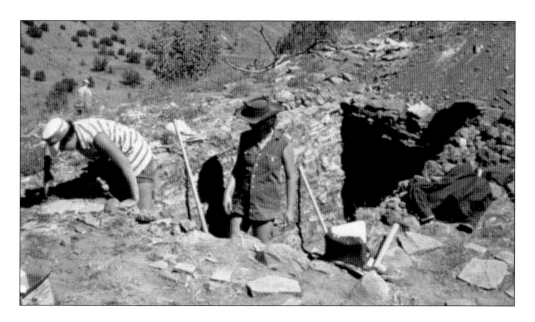

Here is part of the excavation in 1954 of Trench B through one of the site's two refuse heaps (Midden B). This midden is not stratified and was apparently only used for about 50 years. It is clear from the excavations that Largo residents also deposited their refuse in nearby abandoned structures, as well as dumping refuse over the edge of the promontory. Room V-18, shown below being excavated in 1956, is at the south end of room block V. It is superimposed over an earlier structure and may be the remnant of a room fronting a plaza. A partially burned wood fragment was dated to 1368. (Both, BD.)

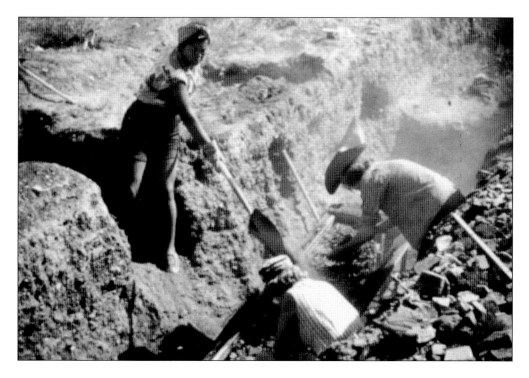

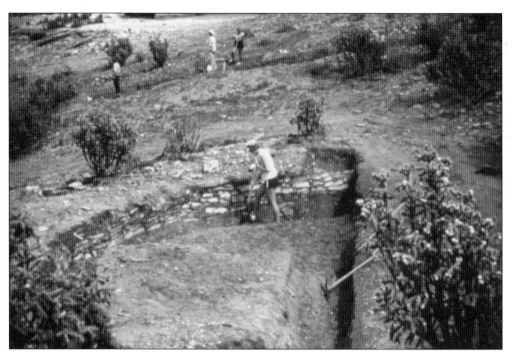

The room being excavated here in 1956 is also in room block V. It is a seven-sided room that was difficult to excavate and even more difficult to interpret. Several wall interiors retained some plaster at the time of the excavation. Fill in the room indicated it might have been used as a trash dump after about 1300. The 1954 photograph below shows the excavation of Kiva B, a circular, semi-subterranean masonry structure located above the refuse heap (Midden B.) A trench through this midden is visible in the background. It probably dates to the first half of the 15th century. Unfortunately, the excavators did not reach the floor and took no wood samples for dating. (Both, BD.)

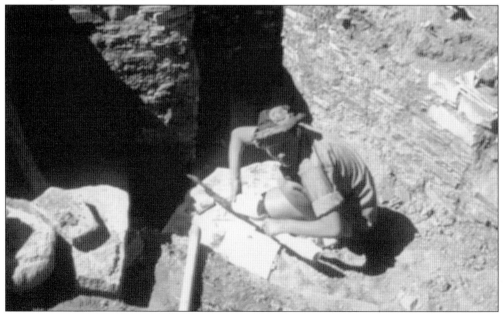

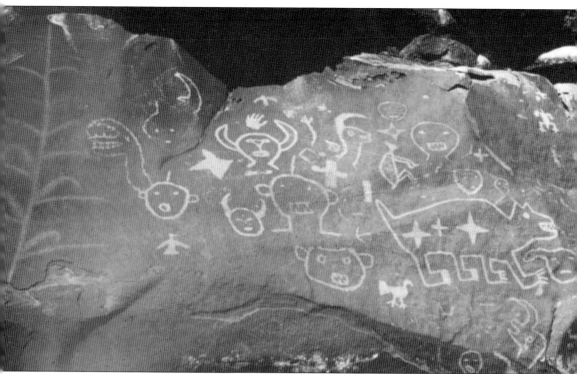

Until recently, the focus of archaeology has been on individual habitation sites, but these are only one part of a cultural landscape that includes spiritually significant locales, agricultural areas, hunting blinds, and water sources. Pictograph (painted) and petroglyph (pecked) rocks are common in the Galisteo Basin. There are numerous such sites, often associated with specific pueblo communities. Much of the symbology is enigmatic and highly conjectural, and although an image may be superficially clear, the full meaning to those who made it is now lost. This petroglyph panel has a range of images: corn, the one-horned snake (Awanyu), stars, turkey, bear, and masked heads. (AMNH No. 490.)

The rectangular painted image seen here appears to be a textile or pottery type of design, with a range of possible interpretations. In the upper-left corner is a face, probably a masked being that looks much like the face often found on the morning star katchina. While it is fun to speculate about such images, in the end we will never know their full meaning. All of the rock art presented in this chapter was photographed by Nels C. Nelson in 1912, significant portions of which have been documented in subsequent years. Below is a panel that has images of sacred beings, including a morning star katchina, a powerful figure said to be associated with warfare. Note the graffiti, an ongoing problem. (Left, AMNH No. 202; below, AMNH No.496.)

This figure is a shield warrior typical of depictions of such figures made for hundreds of years throughout the Southwest. The shields often have feather decorations with sun motifs, as seen here. The spear is decorated with a pendant feather. Such shield bearing warriors were well known to the Spanish. The bear seen below is not an especially common motif, although they do appear from time to time on Galisteo Basin rock art. This is one of the best-known depictions of a bear, with particularly lifelike proportions and an interesting use of positive and negative space. Bears are often associated with a specific clan in current pueblos. (Right, AMNH Nos. 510/511; below, AMNH No.279.)

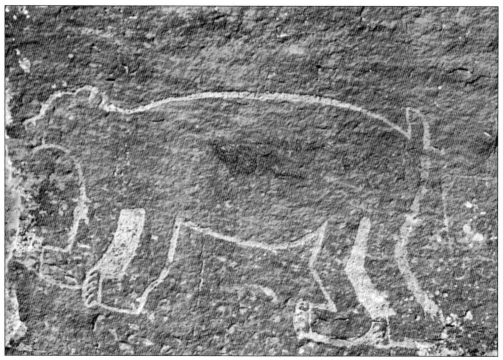

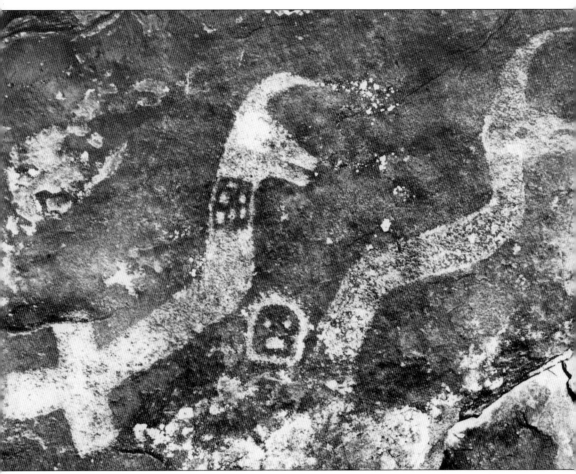

Here are some of the best images of Awanyus, or horned serpents, found in the Southwest. Often said to be Quetzalcoatl, a Mesoamerican deity that slithered up to New Mexico in prehistoric times, the Awanyu may well be an independent invention of the American Southwest. There are important differences between Quetzalcoatl and the Southwest's Awanyu: Quetzalcoatl is a depiction of an anthropomorphic deity in the form of a serpent with a feather collar, whereas the Awanyu is said to be an actual creature, (reported as having last been seen in the 1940s), with a dog-like head, pointed teeth, and a single horn, as well as a lack of feathers. (AMNH No. 203.)

Girl Scout Claire "Squeak" Yeagley, one of Dutton's Dirty Diggers, takes a break in the summer heat in 1955. The Pueblo Largo project was a milestone because its field crew was composed entirely of high school girls rather than college students. They learned proper excavation and recording techniques, thereby gaining an understanding of scientific methods. (BD.)

# DISCOVER THOUSANDS OF LOCAL HISTORY BOOKS
## FEATURING MILLIONS OF VINTAGE IMAGES

Arcadia Publishing, the leading local history publisher in the United States, is committed to making history accessible and meaningful through publishing books that celebrate and preserve the heritage of America's people and places.

## Find more books like this at
## www.arcadiapublishing.com

Search for your hometown history, your old
stomping grounds, and even your favorite sports team.

Consistent with our mission to preserve history on a local level, this book was printed in South Carolina on American-made paper and manufactured entirely in the United States. Products carrying the accredited Forest Stewardship Council (FSC) label are printed on 100 percent FSC-certified paper.

MADE IN THE USA